The Care and Handling of Art Objects

The Care and Handling of Art Objects

PRACTICES IN
THE METROPOLITAN MUSEUM OF ART

Revised edition

by Marjorie Shelley

with contributions by
members of the curatorial and conservation
departments of The Metropolitan Museum of Art

illustrations by
Helmut Nickel

The Metropolitan Museum of Art
Yale University Press

PUBLISHED BY

The Metropolitan Museum of Art, New York
John P. O'Neill, Editor in Chief
Barbara Burn, Executive Editor
M. E. D. Laing, Editor
Peter Oldenburg, Designer

Fifth printing, 2000

LIBRARY OF CONGRESS CATALOGING-IN-PUBLICATION DATA

Shelley, Marjorie
 The care and handling of art objects.

Bibliography: p.
 1. Art objects—Conservation and restoration—
Handbooks, manuals, etc. I. Title.

NK1127.5.S52 1987 069.5'3 82–10608
ISBN 0–87099–318–6
ISBN 0–300–08583–4 (Yale)

Cover design by Steffie Kaplan
Typeset by Burmar Technical Corporation,
Albertson, N.Y.; printed and bound
by Quebecor Printing/Kingsport Press,
Kingsport, TN.

Contents

Foreword

How does one turn the pages of a book or lift a teacup? When is it de rigueur to wear white gloves? Emily Post may provide answers to such questions; but what she has to say is of scant use in the care and handling of works of art. Social and museum etiquette have little in common.

Anyone in the Metropolitan Museum who is entrusted with handling objects in the collection must understand how to open a Book of Hours without bruising or cracking the leaves, how to examine an African mask or a Japanese screen, how to lift a Geometric-period vase dating from the eighth century B.C. (*never* by its handles). And the wearing of gloves is essential for certain objects—arms and armor among them—that would suffer from direct contact with a person's hands.

The purpose in the first part of this book is to provide simple, useful guidelines for dealing with the entire spectrum of works in the Metropolitan Museum: paintings, drawings and prints, textiles, costumes, musical instruments, and three-dimensional pieces, whether monumental sculpture or filigree jewelry. It builds upon the 1946 publication by Robert P. Sugden, then the Museum's registrar; but its frank emphasis on conservation reflects the strides that have since been made in the science and technology of caring for museum collections. We now have a far better idea of what puts a work of art at risk and how that risk can be avoided.

The second part of the book addresses the worst of the dangers: excessive illumination, and fluctuations of temperature and humidity. Too much light dessicates and weakens cellular membranes:

hence the need for frequent rotation of drawings and engravings (indeed, of any work on paper). Variations of temperature and humidity can pry delicate veneers off cabinets and highboys and cause paint literally to fall from the canvas. We maintain climate controls in the galleries not primarily for the comfort of our visitors, but out of concern for the Museum's permanent residents, the works of art themselves.

Although the contents of this book have undergone considerable expansion since it was first undertaken, the idea behind it was always to present certain basic information in a compact and accessible way. At the same time, it incorporates the practical wisdom and experience of a great many people from different departments throughout the Museum. Thanks are due to all those who have collaborated in the enterprise, and in particular to the principal author, Marjorie Shelley, for her skill and dedication in organizing the material.

Philippe de Montebello
Director

Preface and
Acknowledgments

This handbook offers a practical guide to the care and handling of objects in the Museum's collection. It is addressed to all who are responsible for the well-being of the collection or who are permitted access to works of art. While in no way a primer of conservation techniques, it describes the fundamental principles that underlie current Museum practice. I hope that those who consult the book will find it useful, and that the information it contains will also help to answer some of the many inquiries about the preservation of works of art that the Museum receives from private collectors and other concerned members of the public.

The material falls into two parts. In the first, the objects in the collection are discussed by category, with emphasis on the hazards particular to each. Some overlapping of information here is inevitable. For convenient reference, each section ends with a summary of its main points. The second part of the book contains a series of guidelines on matters and procedures affecting the collection in general—such as lighting, photography, and climate controls—with a selected glossary of conservation terms and a short reading list. Finally, since this book makes no claim to be exhaustive, there is space for readers to add their own notes.

The present work is a successor to Robert P. Sugden's *Care and Handling of Art Objects,* which was issued by the Metropolitan Museum in 1946 and has long been out of print. It became evident that a new version, incorporating up-to-date information, was needed, and the task of putting such a handbook together was undertaken at the request of the Curatorial Forum of the Museum.

Special thanks are due to Penelope Hunter-Stiebel and the late Mary Ann Wurth Harris, both formerly of this Museum, who were members of the original editorial committee and who themselves laid the groundwork for the sections on three-dimensional objects and paintings respectively. The contributions by Sondra Castile on Far Eastern works on silk and paper and by Nobuko Kajitani on textiles are also gratefully acknowledged. For their expert advice I am indebted to the late Elizabeth Lawrence on costumes, to Laurence Libin on musical instruments, and to Elizabeth Welch on primitive art. Information and valuable suggestions have been forthcoming from colleagues and former colleagues throughout the Museum, in particular Katharine Baetjer, John Brealey, John Buchanan, Janet Byrne, Sheldan Collins, Mark Cooper, Dianne Dwyer, Betty Fiske, James Frantz, Elayne Grossbard, Yale Kneeland, Marceline McKee, Julia Meech-Pekarik, Richard Morsches, Douglas Newton, Helen Otis, Stewart Pollens, Merritt Safford, Lowery Sims, and Steven Weintraub. Finally, I would like to thank Mary Laing, whose collaborative work as editor has helped so much in the realization of this project, and Helmut Nickel, Curator of Arms and Armor, for his illustrations.

Marjorie Shelley
Conservator
of Prints and Drawings

NOTE TO THE REVISED EDITION

Increasing awareness of the problems posed to art works by inappropriate environmental conditions, coupled with our recognition of their fragility and escalating rarity, has enhanced interest in their care and handling. The guidelines presented in this revised edition, as in earlier printings, are based both on common sense and the experience of conservators, curators, and scientists. The work has been updated by the addition of new conservation findings and product information. For the convenience of readers who wish to mount works on paper themselves, the starch-paste formula used by The Metropolitan Museum of Art is also included. M.S.

1. Three-Dimensional Objects

Most three-dimensional objects in a museum collection have long outlived the life span envisioned by the artists and craftsmen who made them, but they have been preserved, and often repaired when necessary, because of their artistic and historical interest. Archaeological examples pieced together from fragments present the obvious extreme in reconstruction, where a seemingly solid object can prove to be a mass of well-disguised repairs. Objects made from organic materials—that is, plant and animal products—have generally been weakened by handling, and have suffered natural deterioration from the effects of light and of fluctuating temperatures and humidity. Many metal objects have been weakened by corrosion. Everything in a museum collection should, therefore, be treated with respect for its inherent fragility and the vicissitudes it has already undergone.

The people who handle an art object have a critical role. With care and thoughtfulness, they can help to prolong that object's often tenuously extended life; their inattentiveness or haste can

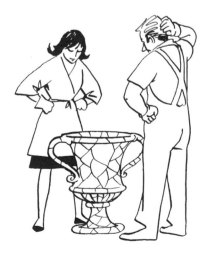

A seemingly solid object can be a mass of repairs. Before handling a piece, examine it carefully to determine the safest approach.

shorten it. The cardinal rule is to avoid all unnecessary handling or touching. If a piece has to be handled, examine it first for its component parts, points of weakness, damages, and repairs, in order to determine the safest approach.

LARGE OBJECTS

The weight of the object will determine how many people are needed to move it. No one person should ever attempt to lift an object if it weighs over 50 lb. If more than one person is to move an object, the method should be understood in advance by all concerned.

When picking up a heavy object, bend at the knee instead of leaning over; the weight should be taken by the leg muscles rather than by the back. Large objects should be transported on a rubber-wheeled flat truck. The route to be taken, door and elevator sizes, and space for the object at the receiving end should be checked before a move begins. Two people should usually be present throughout a move, one of them to open doors, steady the object if necessary, and watch parts of it that the carrier cannot see.

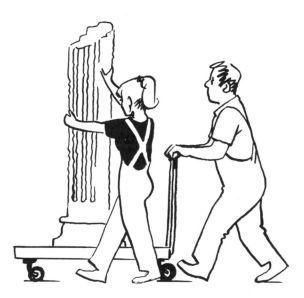

Large objects should be transported on a flat truck with rubber wheels.

Sculpture

A sculpture should be detached from its pedestal and each part moved separately. When minor adjustment of position is necessary after the two have been reunited, the sculpture should be held steady as the pedestal is maneuvered. A pedestal must be sufficiently weighted at the base so as not to be top-heavy when the sculpture is put in place.

A sculpture should be detached from its pedestal and each part moved separately. If a sculpture must be laid down, points of weakness should be supported with padding.

Rigging equipment is needed to move most large sculptures. If a sculpture is too large for a hydraulic lift and must be hoisted, clean blankets should be used to protect it from abrasion by ropes and chains. Tipping of a sculpture should be avoided; not only is there danger of the weight getting out of control and the object toppling, but its base can be abraded. If possible, the sculpture should be kept vertical, in the position in which it was made to support its own weight; a horizontal position puts stress on areas not intended to bear weight. If the sculpture must be laid down, points of weakness, such as the neck of a figure, should be supported with padding.

Furniture

Do not push or pull furniture; pick it up and carry it. Pushing furniture along the floor, even for a few inches, puts tremendous strain on its construction; at the point, for instance, at which a leg is joined to the body, the piece might snap.

Check to see if large pieces were designed to be dismantled for

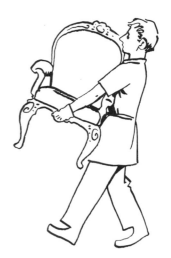

Lift chairs from under the seat rail, not by the arms.

transport. This is often the case with eighteenth-century break-fronts and secretaries, which were constructed in two parts so that the upper section can be lifted off the base.

Furniture should never be grasped by handles, arms, or carved decoration, since it is unlikely that any projection will support the weight of the entire piece. Chairs should be lifted from under the seat rail and not by the arms, which have often been repaired.

Marble tops should be removed and transported separately. They should be moved on their sides, perpendicular to their normal position. They are easier to handle in this manner and are less likely to crack along lines of fissure.

Doors and drawers of cabinets and chests should be locked or secured with ropes so that they do not fall open unexpectedly. A cabinet or chest can then be lifted by two or more persons, each with one hand supporting the piece from below and with the other balancing it on the side.

Most furniture should be transported on flat trucks; marble tops and mirrors may be lashed to side trucks. Be sure that mirrors do not rest on carved decoration; if transported vertically, they should be treated in the same manner as the frames of paintings (see Part I, 3), with padding to support their weight at relatively flat, uncarved points.

SMALL AND MEDIUM-SIZE OBJECTS

Use two hands when moving small and medium-size objects. The best grip is a firm one, but not a tight squeeze. Fingerprints, which can become etched on metal objects, can be avoided by wearing gloves.

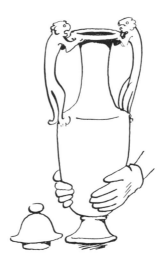

Find the most solid area of an object for the initial grip; never pick up an object by its handles or projecting decoration. Move lids separately.

Do not pick up, move, or hold anything by handles, arms, or projecting decoration. Any projecting element of an old object is likely to have been repaired, and may consequently be weak and unable to sustain weight. Find the most solid area of the object for the initial grip. On a figure, look for a flat area around the waist. Grasp a vase or pot around the sides, after first carefully removing the lid if it has one; transport the object and its lid separately. A cup can be grasped with fingers inside and thumb outside. For jewelry, find the least worked area, such as the ear wire of an earring. Medals and plaquettes should be held by the rim. When possible, remove a supporting mount from an object before lifting it; great care must be taken in separating art objects from mounts, since the objects can easily be damaged in the process.

Immediately after picking up a small object, place one hand underneath it to give support from below. Do not attempt to open

a door or case with one hand while holding the object in the other.

Do not set an object down on a surface which has not been tested beforehand to make sure that it is steady and will bear the object's weight. If an object is to be examined from more than one side or by several people, place it in a padded box or tray and handle the container rather than the object. Ideally, the object should be placed in the container in such a way that it does not need to be steadied during transport. Never put an object on the floor where it can be inadvertently kicked or stepped on.

Try to keep objects upright, since they were designed to carry their own weight in this position. If an object must rest on its side, do not allow it to lie so that a projection carries its weight. Place padding for support under the neck of a vase or figure. Never stack medals and plaquettes, or put them down without padding to protect them from scratches.

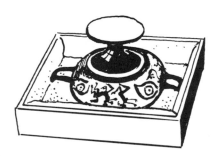

Place small objects in a padded box or tray and handle the container, not the object.

Transport objects by means of a hand-held tray/container or a padded rubber-wheeled tray truck which will not vibrate during the move. When a cart or dolly is used, it should be moved slowly, and care must be taken so that the object carried is not jolted when going over thresholds, elevator entrances, or other irregularities in the floor. Minimize hand carrying by bringing the tray as close as possible to the point of loading or unloading. Do not overcrowd the tray, and be sure that objects do not protrude beyond it. Move parts of objects separately. Do not use pressure-sensitive tape to hold parts together, as this will damage surfaces.

The padding for a container should cover all areas that the art

object might touch. A good material is polyethylene bubble sheeting or mattress padding. Shredded newspaper and wadded tissue paper are not recommended because they may fail to cover all parts of the container; ink stains and smudges can also result from contact with newsprint. For smooth metal, pottery, and stone, separate and cushion objects in the tray with cotton batting or with kapok, which is more resilient; the cushioning should be loose, not tightly packed or putting pressure on the objects. Use tissue paper or polyester fabric where surfaces are rough, irregular, flaking, splintery, or pronged; cotton can snag and dislodge parts. Replace material used for padding as soon as it is dirty, and make sure that surfaces in contact with art objects are clean. Before disposing of packing materials, check them carefully for small objects or fragments that may have been overlooked. Avoid the security risk of transporting precious objects in open trays through public areas.

OBJECTS COMPOSED OF VULNERABLE MATERIAL

Fluctuations and extremes in relative humidity and temperature render many objects, organic and inorganic, vulnerable to chemical and physical deterioration. Various hygrometers for monitoring relative humidity are listed in the glossary. Objects that are unstable as a result of advanced deterioration, or those that tend to absorb and release moisture, are particularly susceptible to such damage. Among them are crizzling, weeping, and devitrified glass, flaking enamels, bronze-diseased objects, lacquerware, polychromed wood, ivory, bone, and leather. Cracking and excessive dryness may occur if organic materials are left near sources of heat, such as direct sunlight, radiators, or even strong incandescent light. In the presence of high humidity, bronze disease may attack various metals, ivory and bone may warp, and salts may come to the surface on ceramic and stone objects. The presence of an adhesive or other nutrient material, such as a gum, used in the original composition or construction of the object or in its repair, will also

increase vulnerability to damage. Depending upon the relative humidity and temperature, organic materials may swell or dry out. In a warm, moist atmosphere they are susceptible to biodeterioration, such as mold growth. Light falling on organic materials will ultimately cause fading and structural damage, hence illumination in gallery and storage areas containing such materials must be maintained at a moderate to low level. (See Part II, 1–3.)

Bronze, lead, iron, steel, and silver are subject to corrosion from oxidation. The condition is particularly critical with archaeological objects in which the process has already begun and which are therefore in a weakened state. Gold objects, which are usually thought of as noncorroding, are at risk if, as often happens, they are alloyed or made with a very thin layer of gold over a baser metal body. The etching or corrosion from fingerprints on metals is irreversible damage. Cotton gloves worn during handling protect these materials from the salts and acids of perspiration, which accelerate corrosion; surgical gloves should be worn instead of cotton if the metal surface is flaking, since a woven fabric might snag and dislodge the flakes.

Rust is a critical problem with arms and armor. Never touch polished steel directly: skin acid and salts will permanently etch fingerprints into the surface. Pick up a sword or gun by the handle and rest the blade or barrel on a gloved hand or covered forearm to avoid handling the steel elements. A layer of dust on steel will attract moisture, which will cause rust; unsealed plastic bags or a loose plastic (polyethylene) wrapping will protect armor while leaving it visible.

Check all materials with which metalwork is to come in contact to be sure that they are acid-free and chemically inert. Whether in exhibition or storage areas, avoid putting metals in contact with oak cases, unseasoned wood, wood-pulp products such as excelsior, rubber-based latex paint, and adhesives used to join acrylic bases and stands.

Organic materials often encountered in primitive art objects require special attention. Strong and weak sites should be determined so that these materials will not be damaged when objects are handled, transported, or stored. Feathers, delicate cordage,

and fibers should not be touched, nor should any parts that are painted, since paint is often loose and can also be stained by fingerprints. Delicate carving or crumbly areas are particularly vulnerable and should not be touched. Primitive objects made of wood often contain areas of insect damage; these should not be grasped because some insects remove all but a thin skin from the infested area, which may collapse if pressed.

Oriental lacquer objects should be stored and exhibited in a carefully controlled environment, preferably at a relatively high humidity appropriate for most organic materials, and at a low light level. Because fingerprints cause permanent damage, gloves should be worn when handling lacquerware. Dusting should be done only with a nonabrasive instrument, such as a blower brush used for cleaning camera lenses.

Pick up a sword by the handle and rest the blade on a gloved hand or covered forearm.

STORAGE

Three-dimensional art objects in storage, as on exhibition, are susceptible to damage from fluctuating temperature and humidity, dust, insects, mold, light, and accidents due to faulty shelving or handling.

Fluctuating temperature and humidity cause organic materials alternately to expand and contract. Although the amount of expansion and contraction may be small, it can result in cracking and breakage. High humidity and dust in the environment may lead to the corrosion of metals. Damage can be prevented by keeping objects away from air vents, radiators, windows, exposed hot- and cold-water pipes, incandescent lights, and exterior walls. Temperature and humidity in storage and display areas can be recorded for week-long periods with hygrothermographs.

Ideally, works of art should be grouped in storage areas according to the sensitivity of their components. For example, organic materials should be stored in a dark place where optimal temperature and relative humidity levels can be maintained. Ceramics, on the other hand, can be kept where the temperature tends to rise and light levels are higher.

Oriental ceramics are often accompanied by lacquer or padded wooden boxes especially constructed for their safekeeping, and should be stored in these while in the Museum or on loan to another institution. Storage conditions should be those appropriate for humidity-sensitive organic materials. A box that is too small to permit adequate packing of the ceramic within it for transport purposes should be sent separately and reunited with the ceramic at their destination.

Storage areas should be clean. Small objects should not be stored on the floor. If dirt is entering the room through air vents, these should be fitted with filters.

If insects or mold are present in a storeroom, immediate action should be taken. In most cases, damage can be arrested by fumigation, but the appropriate eradication program should be determined by the conservator. If insects are seen, they should be caught and identified so that appropriate corrective measures can be adopted. Food and beverages should be kept out of storerooms.

Light from all sources, especially daylight and fluorescent light, rapidly weakens basketry, bark, leaves, cotton, and other plant-based materials, as well as skins, feathers, and other animal products. Light also fades dyes, some paints, and natural feather colors. If these materials are kept in storerooms with windows, daylight

should be filtered through ultraviolet-filtering plastic, and blinds should be pulled when daylight is not needed for work. Fluorescent tubes should be fitted with ultraviolet-filtering sleeves. High light levels in general should be avoided.

Once they have accumulated, greasy dust, soot, and other kinds of dirt may be impossible to remove. Art objects should therefore be kept in cabinets rather than on open shelves, or covered loosely with polyethylene sheeting. All objects should be checked frequently for condensation or any unusual occurrence. Storage shelves should be padded with soft, chemically inert material to prevent objects from being scratched.

Extra care must be taken when moving pieces on and off shelves. The shelves and uprights themselves, and the many surrounding objects, increase the risk of accidental damage. Do not slide an object across a shelf; sliding may cause harmful vibration and abrasions. When an object is placed on a shelf, be certain that it will not roll off it or against another object. Wedges cut from compressible foam can be used to prevent rolling.

Whenever possible, it is preferable to have two people present

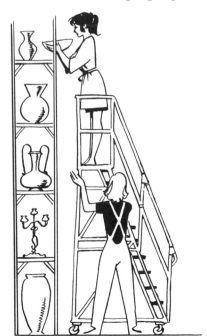

Whenever possible, a second person should be present to help place an object on or retrieve it from a high shelf.

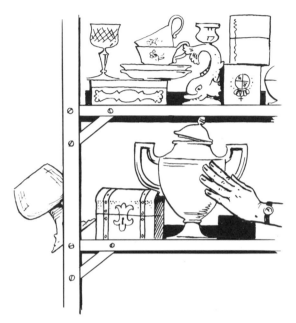

Objects should never be crowded or stacked on shelves. Make sure that objects have enough headroom to be moved on or off shelves without damage.

when a ladder is used to place an object on or retrieve it from an overhead shelf, one to steady the ladder and to pass the object to or take it from the other.

Objects should not be crowded on shelves or stacked. Make sure that there is adequate room above shelved objects so that they can be moved without risk of contact with the shelf above. When there is a shortage of storage space, remember to give works of art priority over supplies, mounts, and similar materials.

Labeling an object in storage with its accession number and any other required information is an excellent means of avoiding unnecessary handling. Labels can be affixed to the plastic sheeting used to cover large objects, or attached to the object with soft cotton string or thread. Wire and nylon monofilaments should not be used to attach a tag; they are too hard as materials and may scratch or dent the object, particularly any soft organic components. Metal-edged tags should not be used, for the same reason. Labels should be made of paper or cardboard and written on in non-smudging ink (felt-tipped pens should never be used).

Adhesive tape, such as Scotch or masking tape, should never be

put on an art object of any kind. It leaves a stain after a period of time, and when removed often takes part of the object's surface with it. If tape is already present on an object, a conservator should be asked to remove it, as the operation usually requires the use of solvents.

Rubber bands should not be used on any metal object, because the sulfur present in rubber causes metal to tarnish.

In exhibition cases, avoid the use of wax, plasticene, and adhesive tapes to stabilize objects. When a work of art is to be photographed, the curator and photographer must decide between them on the most suitable means of support.

ACCIDENTS

If there is an accident during handling, report it immediately to the appropriate curator or conservator. If neither one is present to supervise, carefully collect broken pieces and provide support (such as a cushioned tray) for cracked or weakened areas. Further damage frequently occurs from carelessness in cleaning up after an accident. It is important not to "test fit" broken elements, because rubbing them together along the breaks will make later repair more difficult. Never discard even the smallest fragment after an accident. Never dispose of packing material without checking it for small objects or fragments that may have been overlooked.

Based on contributions by Penelope Hunter-Stiebel, formerly of the Department of European Sculpture and Decorative Arts, and by members of the Departments of Primitive Art and of Conservation

Care and Handling of Three-Dimensional Objects

1. Before handling an object, examine it closely; note old repairs and structural weaknesses, and parts which should not bear weight when it is set down. Do not test or probe areas that appear to be weak.

2. Check to see if the object is constructed in parts so that it can be dismantled and the parts moved separately (this applies particularly to furniture constructed in tiers, sculpture and other objects attached to bases, and ceramics with detachable lids).

3. Never grasp projecting elements (handles, arms, etc.) as they are often repaired and will not support weight.

4. With both hands get a good hold on a solid, relatively flat area and support the heaviest part of the object.

5. Transport objects on rubber-wheeled trucks or trays padded with resilient packing materials to avoid shock and vibration.

6. Minimize the dangers of hand carrying by bringing the truck or tray as close as possible to the point of loading or unloading.

7. If a truck is used, it should be held steady or blocked during loading.

8. Works of art can be irreparably damaged by incorrect methods of cleaning. Only a conservator should undertake cleaning or treatment procedures.

9. Keep trucks clean and replace packing materials when they become dirty; clean off the surface on which an object is to be placed.

10. Whenever possible, gloves should be worn when handling art objects, as acids and salts from perspiration can damage many materials. If gloves are not used, hands should be washed thoroughly. Wear cotton or thin plastic gloves when handling metalwork and lacquer, as advised by the curator or conservator.

11. Maintain humidity, temperature, and light at appropriate levels.

12. Report any damage to an object immediately, and collect all fragments before leaving the area.

13. Never dispose of packing material without checking it for small objects or fragments that may have been overlooked.

2. Musical Instruments

Unlike other three-dimensional objects in the Museum—such as furniture, costumes, jewelry, primitive art, or arms and armor—which are never put to practical use, many musical instruments in the collection are occasionally played. Intrinsic qualities are revealed in performance that cannot be appreciated by sight alone. Whether an instrument is played depends upon its condition and the circumstances of the performance. Only highly qualified musicians are permitted to use the instruments, and then only under supervision and for purposes of research. Certain instruments have been made available for recordings and for concerts in the Museum, but instruments are not loaned out for performances nor are they available for practice. Under no circumstances is any instrument to be played, tuned, or handled without permission of the curator in each instance, and without immediate supervision. The preservation of the instrument must always be the primary consideration.

The Museum's instruments are composed of a vast array of materials ranging from ceramics, woods, metals, glass, and polychromed and inlaid surfaces to cloth, paper, shells, cocoons, feathers, and skins. Thus, the reader interested in the care and handling of musical instruments should also consult other sections of this handbook, such as those on three-dimensional objects, paintings, and textiles.

Aside from the physical properties of individual materials, their combination in one object involves different coefficients of expansion and a variety of joints and adhesives; thus, fluctuations or sudden changes in temperature or humidity may cause irreversible structural damage, especially in a woodwind (because of warm, wet breath) or in a stringed instrument or drum, where the vibrating element is under tension. Upsetting the delicate balance of stresses in an instrument affects not only its appearance and integrity but also its sound, often through invisible changes in the internal parts. The close tolerances of valves and keys and the intricate mov-

ing parts of music boxes and pianos are subject to subtle damage through wear. Woodwinds and drums have to be gradually warmed up for use, a process that may take hours or days; they should be played only for limited periods, then carefully dried or cleaned. Strings and drumheads should not be kept under high tension for extended periods, and frequent changes of tension (as through tuning) should be avoided.

Whether or not they are played, the environment in which instruments are displayed or stored must be maintained at a steady 68° F (20° C) and 50 percent humidity; the Museum's instruments are acclimated to this standard, which represents an acceptable compromise for most materials. Instruments with organic or light-sensitive components must be kept out of direct sunlight and unshielded fluorescent light to avoid photo-oxidation damage. Heat from spotlights or photographic flood lamps can lead to desiccation and color changes; it can also melt wax joints, shrink skins and gut strings, and throw instruments radically out of adjustment.

Gloves should be worn to protect polished brasses and varnished stringed instruments such as violins. The varnish on such objects is an extremely critical aesthetic and protective element which, unlike that on a painting, is never to be removed and replaced. Every effort must therefore be made to reduce contact with skin oils by handling an instrument only by its neck and edges. Performers must remove jewelry and use chin pads where necessary; hands must be clean. Painted wooden instruments should be handled with the same consideration and forethought as panel paintings. Wind instruments are often made of several loose-fitting sections; care must be taken in lifting and carrying them so that the sections do not separate. Where possible, a specially fitted carrying case, in preference to an open tray, should be used for transport and temporary storage.

Two or more people should accompany any large instrument when it is transported—even if it is on a truck—to facilitate movement through corridors, doorways, and elevators, and to prevent visitors from touching it. When an instrument is moved from one area of the building to another (especially from an air-conditioned area to a hallway which may be very hot or very cold), it should be

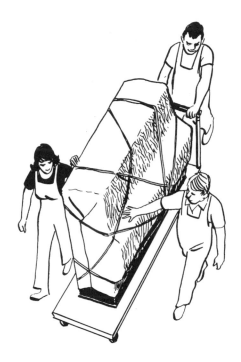

Two or more people should accompany any large instrument being moved on a truck. Cover instruments to avoid thermal shock, and always transport keyboard instruments upright.

covered to avoid thermal shock. Instruments should not be dismantled for transport without supervision, owing to their complex structures and the risk of injuring the mechanisms and sounding parts. Keyboard instruments should be moved in a level position, never tipped or carried sideways. Harpsichord lids and similar flat parts, if moved separately, are to be lashed to padded side trucks. Small instruments or components should be placed in the padded shelves of tray trucks (if fitted cases are unavailable) and the rules given for small objects (see Part I, 1) should be followed.

An instrument must never be allowed to rest on or be lifted by its keys, bridge, strings, or other fragile, finished, or loose parts. Because the sizes, shapes, weights, and balance points of instruments are so varied, the placement and handling of each one must be considered individually. Vulnerable instruments must never be placed near uninsulated outside walls, heat sources, or air vents, or below water pipes or ducts from which condensation may drip. All

shelving, drawers, and uprights must be adequately padded with inert soft material. Any wood shelving in storage or display areas should be sealed with a stable varnish such as polyurethane. Oak should be avoided for shelving; the vapors it gives off may damage susceptible materials. A light sheet of inert plastic or a pierced polyethylene plastic bag over a layer of acid-free tissue or muslin may be used for dust protection, but surfaces should be checked regularly to guard against condensation and collection of dust. Polyvinyl chloride and cellophane are unstable and must never come in prolonged contact with an instrument. Any signs of mold growth, insect infestation, or other unusual condition must be reported immediately and treated by a conservator. In handling instruments on ladders or platforms, appropriate safety precautions should be observed at all times.

Adhesive of any type, including tape, wax, and plasticene, must never be used to support instruments for photography without the consent of the curator. Rubber wedges or another nonstick material can be used to brace the object, but rubber in any form must not be left in contact with it for a prolonged period. Certain instruments may be suspended from nylon cord, but this and all other temporary mounting must be done under supervision. Brass, silver, and other metal instruments are extremely sensitive to atmospheric pollutants; they must never come in contact with residues from photographic chemicals. Because of this, anyone photographing such instruments who has previously been using fixers must be especially careful to have clean hands or to wear gloves.

Care and Handling of
Musical Instruments

1. Resist the temptation to play or manipulate an instrument; do not, for instance, pluck strings, blow on reeds, tighten strings, or press keys.

2. Temperature and relative humidity must be maintained at prescribed levels and checked at least daily.

3. Wear gloves to handle instruments with varnished wood and polished metal surfaces.

4. No instrument is to be dismantled, no matter what its size, without supervision.

5. Protect instruments in storage and transport by resting them on padded surfaces and using dust covers.

6. Any instrument with loose parts or flaking should be brought to the attention of the conservator.

7. Adhesives must never be used to brace an instrument for photography or display without the consent of the curator.

3. Paintings

PAINTINGS ON CANVAS AND PANEL

In the handling of paintings, the care and experience of the handler provide the best insurance against damage. The moving and installation of pictures and their removal from exhibition should be supervised by a responsible member of the staff.

No more than one painting should be handled at a time; large panels and canvases—with or without heavy frames—should be moved by two or more persons. Frames afford some protection, and a painting is safer with a frame than without one. It may occasionally be necessary to carry an unframed painting by the stretcher, but canvases and panels should be grasped at the edges only. Special care should be taken to protect from dirt and fingerprints twentieth-century paintings that have areas of exposed canvas. In this case, thin cotton gloves may be worn. Framed paintings should be carried with both hands, one beneath and one at the

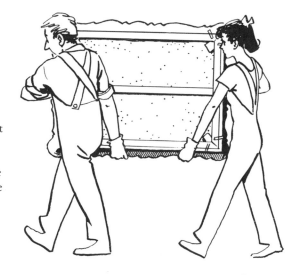

Large panels or canvases should be carried by at least two people. Carry framed paintings with two hands, one beneath and one at the side; always grasp the frame at a solid place.

21

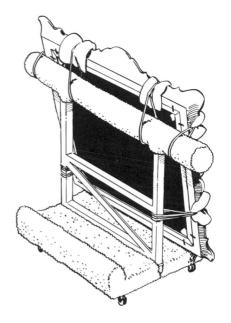

Whenever possible, move paintings—securely lashed in place—on a padded truck.

side of the frame, always at a point where the frame is solid; check the frame first for old breaks, repairs, and points of weakness. Never lift or carry a framed painting by the top of the frame, or by its stretcher.

Whenever possible, pictures should be moved on a side truck rather than carried by hand. The truck should have a padded floor with a lip along the front and back, and it should not be overloaded. The paintings should be securely lashed in place before the truck is moved, and should be accompanied by two or more persons while the truck is in motion. The structure of the truck must support at least two-thirds of the height of a painting; very large paintings should therefore be placed on the truck on their longest sides. If the picture is substantially wider than the truck, a two-by-four piece of lumber, wide enough to support both stretcher and frame, should be lashed to the top bar of the truck; the weight of a picture should never be borne by the stretcher alone.

The stacking of paintings and frames on trucks or in storerooms is inherently risky and must be avoided if possible; both frames and painted surfaces can be damaged. If stacking is unavoidable, it

must be done with the utmost care. Paintings and frames should be stacked upright, never laid flat, and padding must always be inserted between each item at the corners and wherever there is projecting ornamentation. The padding may be paper bolsters or some other soft material. Twentieth-century paintings, many of which have areas of exposed canvas and fragile paint layers, should always be covered while in storage with a smooth acid-free paper, such as acid-free glassine, to protect them from abrasion, fingerprints, and airborne dirt. Sheets of acid-free board may also be inserted between paintings stacked in storage racks as additional protection for the painted surface. No more than five pictures should be placed in any stack, and all pictures in a stack should be similar in size. The paint surface should never come in contact with padding materials placed at the corners or between paintings in a stack.

Place felt pads with rubber skidproof bottoms under pictures standing against gallery or storeroom walls. Set heavily ornamented frames on lengths of two-by-four lumber covered with carpet or felt. To avoid all chance of slippage or accidental abrasion by a passerby, hang pictures on gallery walls or storeroom racks as soon as possible.

When hanging a picture, make certain that the supporting wires and fixtures are strong enough to bear its weight. Screw eyes and dangling wires should be removed from the frame as soon as a picture is taken from the wall; screw eyes can damage the frames of other pictures in a stack, and dangling wires can abrade any paint surface with which they come into contact.

It should never be necessary to touch the surface of a painting. Fingerprints on paint surfaces or on frames can damage and spoil the finish. They cause some varnishes to bloom and might thereby necessitate treatment of the whole surface.

The security of a canvas in its frame should never depend on nails; they work loose too easily and fall out. It is preferable to use metal brackets bent in such a way that when one end is screwed to the frame, the other end will press against the stretcher. Paintings on wood require flexible brackets to allow the panel to expand and contract. Pieces of cork or rubber, perhaps in combination with

To secure a canvas in its frame, use metal brackets not nails. If a frame is too large, pieces of cork or rubber can be used to adjust the space.

strips of wood, can be used to adjust the space between a painting and its frame if the latter is too large.

A painting should be held in its frame in such a way that the edges of the paint surface cannot be chipped or abraded. Whenever possible, thin strips of dark-stained wood should be fixed to the outside edges of the stretchers supporting paintings on canvas. The strips should be fitted so that they project forward sufficiently to prevent the rabbet of the frame from rubbing against the edges of the paint surface. If the rabbet is not large enough and cannot be cut back, then the edges of the paint surface can be protected by lining the face of the rabbet with strips of adhesive felt. The edges of paintings on wood panels can be protected only with strips of adhesive felt attached to the rabbet.

Adjusting the securing stretcher keys and removing objects that become wedged between canvas and stretcher are the responsibility of a conservator and should not be attempted by anyone else.

Labels should not be applied to the backs of canvases. They may cause the portion to which they are attached to expand and contract at a rate different from that of the rest of the canvas, with resultant cracking and possible flaking; the chemicals in the adhesives can also seep through the canvas and adversely affect the paint on the other side. A backing of, for example, cardboard, Foam-Cor, or Masonite will protect the painting from blows to the reverse and from dust; to allow for the circulation of air, small holes should be cut in the backing before it is applied.

At no time should anyone but a conservator touch the painted surface or the back of a canvas, not even for the removal of dust; pressure of any kind may disturb the paint surface. Paintings should not be treated with oil of any kind, solvents such as alcohol or benzine, commercial cleaning preparations, soap, water, erasers, bread crumbs, raw potato, or household cleansers. *Neglect is less dangerous than inexpert treatment.* If there is any doubt about the condition of a painting, or if it has been damaged accidentally, it should be left untouched until it can be examined by a conservator.

Owing to the often mercurial nature of the media used in twentieth-century paintings, it is advisable to secure information about technique and process (from the artist if possible) when such a painting enters the collection. This will assist in the future care of the work.

Extremes of temperature and humidity are bad for paintings. The temperature of galleries and storage areas should stay within the range of 68°–72° F (20°–21° C); a steady relative humidity of about 50 percent is desirable. Heat, including heat from photographic flood lamps, is particularly dangerous to lined canvas and panel paintings. It will soften waxes (thereby attracting dust), cause distortion and bulges, and promote pinpoint flaking. Paintings should therefore not be hung near windows, radiators, or heating vents, or otherwise exposed to heat (particularly that from photographic lamps) for prolonged periods. HMI lamps radiate minimum heat and are recommended for photographing paintings, particularly panel paintings. The sensitivity of paintings to ultraviolet and visible radiation varies considerably depending upon the pigments, binding media, and presence or absence of varnish. Illumination should not be excessive, nor should paintings be hung in direct sunlight. The conservator is to be consulted for the appropriate lighting conditions in gallery and storage areas. In storage, pictures should have some access to light and air; light cotton dustcovers may be used if necessary, but plastic sheeting in direct contact with the object can cause dangerous problems of condensation and is not recommended.

Report any damage, however slight. If paint flakes or parts of

frames become detached, save all the pieces, for repairs are much easier if these are available. Keep a record of all damage and repairs.

Based on contributions by the late Mary Ann Wurth Harris, of the Department of European Paintings, and by members of the Departments of Twentieth Century Art and of Conservation

PORTRAIT MINIATURES

Frequent examination of a miniature collection and careful control of the environment are the best safeguards against such common problems as warping of the support, flaking, and the emergence of mold growth.

Unframed miniatures on ivory and vellum, both highly hygroscopic materials that respond radically to even minor fluctuations in relative humidity, are exceptionally fragile. The warmth and slight perspiration of a hand, as well as pronounced changes in relative humidity that may occur during display, storage, or photography, can quickly cause an ivory miniature to warp or to crack along the grain, or cause a vellum miniature to cockle. When this occurs, areas of the weakly adhering paint layer, usually watercolor or gouache, are apt to flake. In addition, over the course of time the binding media in the pigment will often dry out, leaving it semipowdery and easily disrupted by any mechanical action, even a very slight inadvertent brush with the tip of the finger.

Because of the delicacy of both the painted surface and the support, unframed miniatures should be handled as little as possible and with extreme caution. When it is not necessary actually to touch the unframed object, a small sheet of thin ragboard with a beveled edge can be slid beneath the miniature to support it. When a miniature must be handled, it should be held between the fingertips, with the slightest possible pressure, at its top and bottom edges, which on an ivory miniature are usually the end grains. Pressure at the sides will cause the miniature to bend and

thus provoke paint flaking or splitting. Cupping a miniature in the palm of the hand is dangerous, as these hygroscopic materials are particularly sensitive not only to moisture and heat but also to the oils in the skin. Obviously, care must be taken not to touch the painted surface.

Miniatures painted in oil or enamel on metal pose conservation problems comparable to those for larger easel paintings in the same media. To avoid one of the most serious conditions, pinpoint flaking, it is particularly important that such miniatures not be exposed to high heat levels.

Only a conservator or experienced expert should attempt to remove a portrait miniature from its sealed frame case or try to refit one. The cases, which can have the intricacy of fine jewelry, are often complicated in structure, the components are very small, and their assembly is not always straightforward. Pressure on any of the parts can lead to serious damage, including splitting, breaking, or abrasion of the paint layer.

Ordinary flat glass or acrylic sheeting should never be used to reframe miniatures. Almost all miniatures were originally glazed with a convex glass crystal. This shape does not rest on the painted surface and thus will not mar it. The air space a convex crystal provides also limits the likelihood of condensation staining should there be a drastic drop in temperature.

Both framed and unframed miniatures are subject to mold. Gums, sugar, or honey, traditional binding agents for pigments, are nutrients for micro-organisms, which will flourish in an atmosphere of high humidity. Most frequently, mold appears as a pale gray bloom on the painted surface or on the underside of the glass. Any such condition should be brought to the immediate attention of a conservator for fumigation or treatment.

Cleaning of framed miniatures by those other than experts should be limited to the use of a soft, dry cloth. Metal polishes, soap and water, alcohol, or any other liquid must never be used. Fluids can easily seep into crevices in the case, quickly blurring the painted surface and damaging the support and the unexposed parts of the frame.

Cotton batting is not suitable for storage of unframed miniatures because the fibers may catch and dislodge partially detached paint flakes. Velvet is more suitable, and its surface will also help to prevent the object from sliding. If a framed miniature is to be wrapped, it should be wrapped loosely with acid-free tissue. Both framed and unframed miniatures may be stored in flat, acid-free boxes with separate compartments for individual miniatures and for the various mounting components. There should be sufficient space surrounding each object to permit its safe removal, either with the fingertips or by means of a piece of ragboard slid beneath it as a support.

To avoid such problems as surface deformation, splitting, mold growth, and paint flaking, relative humidity should be maintained at 50 percent and temperature at 68°–72° F (20°–21°C). Miniatures done in watercolor or gouache must be protected from fading. Because it is not possible to use ultraviolet-filtering acrylic sheeting for framing, miniatures should be kept in darkness when not on exhibit. During an exhibition, light levels should be kept between 5 and 8 footcandles. Display of miniatures should be limited to three months or less per calendar year.

Care and Handling of
Paintings

PAINTINGS ON CANVAS AND PANEL

1. No one but a conservator should touch the front or back of a painting whether on canvas or panel.

2. No more than one picture should be handled at a time. Large paintings should be moved by two or more persons. Carry a framed picture with one hand beneath and the other at the side of the frame, where the frame is solid. Never carry a painting by the top of the frame or by the stretcher. An unframed canvas or panel should be held at the edges only, and thin cotton gloves may be worn to avoid marring the surface.

3. Whenever possible, move paintings on a side truck. Enlarge the supporting framework of a truck when necessary to support an outsize frame and stretcher. Lash paintings in place before moving the truck.

4. Do not stack paintings unless absolutely necessary. If paintings have to be stacked, separate the frames with soft padding at the corners. Place paintings that must stand temporarily on the floor on skidproof pads or padded wooden two-by-fours.

5. Remove screw eyes and wires from frames as soon as pictures are taken from the walls.

6. Frame pictures in such a way that the edges of the paint surfaces are not damaged. Avoid fingerprints on the edges of the paintings and on the frames.

7. Do not expose panel or canvas paintings to heat from any source, including photographic lamps. HMI lamps are recommended for photography, particularly of panel paintings.

PORTRAIT MINIATURES

1. To lift an unframed miniature, support it with ragboard.

2. Hold unframed miniatures with the fingertips at the top and bottom edges only. Do not cup in the palm of the hand.

3. Do not expose miniatures to light and heat. Miniatures should be on display for no more than three months a year. Keep light levels during an exhibit between 5 and 8 footcandles.

4. Maintain approximately 50 percent relative humidity and keep temperature at 68°–72° F (20°–21° C).

4. Works on Paper and Books

WORKS ON PAPER

Works of art on paper, a category which includes prints, drawings in all media, pastels, photographs, and works on related materials such as parchment and papyrus, are among the most vulnerable of objects. They are readily damaged by mishandling, excessive light, fluctuations and extremes of temperature and humidity, and the materials with which they come in contact.

Lighting, climate, and fumigation

Works on paper are highly sensitive to the effects of any type of intense illumination and should not be exposed to direct sunlight, unfiltered fluorescent lamps, or the heat of incandescent bulbs. The ultraviolet rays from sunlight and fluorescent tubes will cause structural damage and oxidative reactions such as yellowing or bleaching of paper, and will alter the color of many pigments. The heat from tungsten lighting causes drying and embrittlement. Light levels in gallery and storage areas (see Part II, 1) should be kept low, at 5–8 footcandles. The eye is capable of adapting to low illumination (adaptation will be quicker if adjacent galleries are not brightly lit), and limiting light exposure will protect paper and pigments from chemical and physical deterioration. For an individual work of art, exhibition time (both within the Museum and on loan) over the course of a calendar year should not exceed three months. In storage, to protect from light as well as dust, matted and unmatted works on paper should be kept in solander boxes or acid-free folders. Framed works of art that cannot be kept in solander boxes should be protected from light by a cover of dark paper or cloth. Lights should be turned off when not needed. Works on paper must never remain uncovered if not on display or being examined.

Whereas storage or display in a very dry atmosphere (below 45 percent relative humidity) will result in desiccation and accelerate aging, a humid environment (above 65 percent relative humidity) and lack of ventilation will encourage the growth of mildew, mold, and foxing (dark red-brown spots). Temperature and relative humidity should be monitored in gallery and storage areas with hygrometers or recording hygrothermographs.

The light gray haziness that may appear on the inner side of the glass or acrylic sheeting of a framed picture is often mold growth. It corresponds to places on the verso of a print or drawing, or to pieces of a collage, where paste has been applied. Mold spores are encouraged by moisture, subdued light, warmth, and lack of air circulation, and will attack starches and glues in paper, certain inks, and the gum binding in pastels. If there is evidence of mold or mustiness, books and works on paper (particularly pastels) should be fumigated in an airtight chamber with thymol or ortho-phenyl phenol to arrest development of the spores; only a conservator should undertake this or any other fumigation or disinfection procedure. Thymol should not be used for parchment, nor should it be used if there is any varnish on the art object. Because of the extreme toxicity of ethylene oxide and the long-term hazards that may result from its use, both to persons and to objects, a conservator must be consulted before any insect extermination program using this chemical is undertaken. The long-term effects of para-dichlorobenzene on paper are not known, and therefore its use, or that of any proprietary liquid, powder, or aerosol insecticide, is not recommended for works on paper or parchment or for photographs.

Handling and transport

Preparation and handling of works on paper for exhibition, matting, framing, storage, or shipment should be done by experienced persons only.

An unmounted print or drawing should never be lifted by its corners; the edges and corners of a sheet of paper are its weakest and most brittle areas. Even strong and flexible papers, if handled

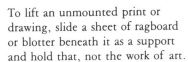
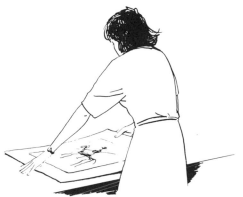

To lift an unmounted print or drawing, slide a sheet of ragboard or blotter beneath it as a support and hold that, not the work of art.

by the corners, are subject to pressure from the fingers, and the resulting fingerprints are often impossible to remove. When lifting an unmounted print or drawing, slide a sheet of ragboard or blotter beneath it (using, if necessary, a micro-spatula or a thin card, not a finger, to get started) and hold the support, not the work of art. If the work itself is to be handled, support the long sides of the sheet with both hands and, if possible, protect the area to be touched with folded tissue paper. Never hold a print, drawing, or photograph, even if it is mounted on a supporting sheet, with one hand; if the paper or its support is brittle, it is likely to crack under its own weight. If an unframed work on paper is to be turned over, place a second clean sheet of ragboard or blotter on top of it. This will allow the object to be reversed without its actually being touched. Do not do this with objects that have powdery or flaking surfaces.

Never shuffle groups of prints or drawings to align their edges, or pull an individual sheet from a pile without first removing all the sheets that lie on top of it. Matted works of art should be opened only from the right-hand corner, never by reaching through the mat window.

Paper clips and staples should never be used with works on paper, and should be carefully removed if they are already present; such devices can cause impressions in the paper, tears, and rust stains.

Wet, sticky, and dirty hands must never touch works on paper. Pens, pencils, and all sharp objects, including screw eyes, wires, and nails, should be kept at a distance.

When transported any distance, individual works of art on paper which are neither framed nor matted and which are not to be carried in a solander box should be supported and covered by sturdy sheets of clean ragboard, or placed in a folder of good-quality blotting or acid-free paper. The size and weight of the work will determine the type of support used, but this should always be larger than the work and should not allow it to bend. Groups of matted or unmatted drawings, prints, or photographs to be moved should be placed in a solander box and transported on a cart. For storage or transport, a work on paper, no matter how large in size, must never be rolled on itself or in a tube. Rolling can promote flaking of inks and pigments, distort fibers, and cause tearing or creasing if the roll is crushed.

Mounting

Several publications that give detailed procedures for mounting prints and drawings and other tested formulas for hinging made of rice or wheat flour are noted in the reading list at the of this book. The starch-paste formula used by the Metropolis Museum's Paper Conservation Department is given on page

Only long-fibered Japanese tissues of high quality are re mended for hinging. For most works on paper, hinges sh placed along the top edge of the verso of the sheet. Mask transparent pressure-sensitive tapes are very destructive never to be used. Adhesives on those tapes usually become with age, and it is difficult to remove them without tearing the paper to which they are attached. The most of them leaves a brown stain that is frequently remove and a residue that penetrates the fibers of the the area of attachment appear translucent. Rubber highly destructive, ultimately causing dark brown the sulfur it contains. Rubber bands will cause Many water-based synthetic adhesives are also ha

their chemical alteration over time; their improper application also frequently causes rippling of the support. The tendency of paper to ripple or buckle slightly is a natural response to changes in atmosphere. Works on paper should therefore never be dry mounted or pasted to a support either completely or along the margins; both methods of mounting prevent the natural expansion and contraction of the material, and thus may lead to its tearing. Works already dry mounted should be brought to the attention of a paper conservator. Where the window and backboard of a mat have been pasted together around the margins, do not attempt to pry the layers apart, as the print or drawing can easily be torn. Care must be taken in lifting hinged prints or drawings from their mats, since the method of hinging and the number of hinges used will often vary from piece to piece.

Accession numbers are to be written on the verso of prints and drawings in soft pencil only and in a small, neat hand. Because of the differences in opacity among papers, and the differences in density and stability of inked or pigmented areas, the location of the accession number is to be determined by the curator or conservator. Brittle or fragile sheets, such as tissue or tracing papers, and drawings in which the ink appears corrosive are to be imprinted with the Museum accession stamp only by the conservator.

Matting and interleaving

Mats, protective separators, interleaving and backing papers, storage-box linings, and folders provided for use with prints, watercolors, and similar art objects must be of 100 percent rag fiber or other highly purified pulp, such as buffered sulfite. Low-quality materials made of wood pulp, no matter how satisfactory their outward appearance, yellow and embrittle with time. Of greater consequence, their inherent acidity causes severe and often irreversible damage to the work of art with which they are in contact. Matboard composed of a wood-pulp core and outer layers of rag paper is not satisfactory as ultimately it, like solid wood pulp, will cause a sharp line of brown discoloration—known as a mat burn—on the

Any work of art that runs the risk of flaking should have a double-window mat, so that the interleaving material (acid-free glassine is recommended) does not rest on the surface of the work.

face of the work of art, owing to the migration of acids. Such material will similarly discolor the back of the print or drawing. As contact with alkaline substances can also damage albumen and color photographs, only nonbuffered, acid-free tissue and ragboard are to be used with this material.

The surfaces of both matted and unmatted drawings and prints, whether they be stacked for transport or storage, should always be protected with acid-free interleaving materials, such as glassine or buffered tissue, or, as a temporary measure, with blotting paper, to guard against rubbing and abrasion. In the case of a matted drawing or print in good condition, interleaving paper is inserted directly on the face of the work of art. Where the possibility of flaking exists (as in Islamic and parchment paintings and in gouaches), a double-window mat should be used, with interleaving material placed between the window layers rather than directly on the delicate surface of the composition. Most glassine has a tendency to yellow and become acidic; it should be replaced periodically. Even acid-free glassine, which is recommended, should have its pH checked after it has remained in contact with a print or drawing for a period of years. Buffered tissue has better aging

properties; it is, however, opaque, and more handling will be required to view the work of art. Never affix a label with tape to interleaving paper or tissue. The adhesive can bleed through and damage the work of art.

Plastic film, such as polyester (Mylar), is also used in double-window mats to protect drawings. In this assembly, the sheeting is attached with nonbleeding tape to the underside of the outer window; the inner mat window thus separates the plastic film from the work of art. The double-window mat provides immediate visibility, minimizes handling, and eliminates the movement of paper or tissue across the surface of a drawing. Plastic films, however, generate a static charge when rubbed, and in so doing accelerate flaking and attract dust. They must therefore never come in direct contact with the work of art, and should *never* be used with pigmented surfaces that are in danger of flaking. When plastic film can be safely used, an antistatic solution to cut down the collection of dust should be applied to both sides of the film before assembly in the mat. Under no circumstances should a work on paper be folded to fit into a mat; a larger-size mat should be provided to accommodate the object.

Framing and glazing

When framed, works on paper must always be separated from the glass, either by a mat or by lifts inserted under the frame rabbet. The distance provided by the mat or lifts will protect the paper and pigments from mold damage and staining due to condensation (which results from a rapid drop in temperature) on the inner side of the glass. If moisture is present, works of art on paper that are framed without a lift or mat may stick to the glass. This is a particularly serious problem with photographic emulsions and with prints and drawings coated with gum arabic or gelatin. The protection of a mat or lifts in the frame is also essential for weakly held layers of paint, such as are found in Islamic, Indian, and parchment miniatures and in gouaches, charcoals, and pastels, which will often leave an impression—i.e., some pigment—on glass if pressed against it for a long period of time.

Where a composition is in no danger of flaking, acrylic sheeting—such as Plexiglas or Lucite—with an ultraviolet absorber should be used in preference to glass, to protect the work of art against photochemical or light damage and to avoid physical damage in the event of the glass shattering. The acrylic sheeting commercially available has different levels of effectiveness. For example, UF-3 Plexiglas filters out most of the harmful ultraviolet radiation, but has a faint yellow cast; UF-4 Plexiglas filters slightly less, but is clear in color. If UF-3 or UF-4 Plexiglas or a similar product is used, a notice to that effect should be affixed to the backboard of the work framed. Ultraviolet-filtering plastic should be used with caution on color photographs, since the transmission of light through it has been found in some instances to lead to uneven fading and color alteration of certain dye layers. Acrylic sheeting, like other plastic film, must be treated with an antistatic solution, and like glass it must always be separated from the work of art.

Pastels, charcoal drawings, and Islamic miniatures present special problems in glazing and handling, owing to the weak attachment of their pigments to paper. Because of its static charge, acrylic sheeting is unsuitable as a glazing medium for such works. Glass must be used, in conjunction with a thick (¼-inch) lift or mat to prevent contact between it and the picture. Except for conservation or special circumstances, pastels are always to remain in their frames. When unframed, they should not under any condition be stacked or placed face down; nor should their surfaces ever be touched. When transported, unframed pastels should be placed face up in an individual solander box larger than the composition, and moved on a wagon. It is imperative that a picture that cannot be glazed with acrylic sheeting be stored in the dark or under cover, and that when it is exhibited, light be maintained at the lowest possible level.

Good-quality material must be used on the back of the framed work. Wood or ordinary corrugated cardboard should never be used for this purpose. Because of their acidity, both will stain (leaving imprints of knots, or dark and light stripes) and discolor paper. Cardboard also tends to absorb moisture and is not resilient

enough to withstand accidental puncturing. Two to three layers of 4-ply ragboard, buffered-sulfite board, or acid-free corrugated board (separated from the art object by a layer of ragboard) will usually provide adequate protection for backing most framed works.

In framing, a brad-setting tool should be used rather than a glazing gun, which shoots glazing points into the frame. The former sets the brads without jarring the work of art, and hence avoids any risk of pigment loss.

If framed pictures have to be stacked, cardboard or another resilient material should be placed between them to protect the glass or acrylic sheeting (which scratches easily) and the frames. To prevent slippage, the pictures should be placed on rubber pads and one or more heavy weights should be propped in front of the stack.

Unframing

The safest procedure for removing a work on paper from its frame is to lay it glass down and to lift out each layer of backing separately (pastels are an exception, since they must not be turned face down and should be unframed only by a conservator or another experienced person). In many instances, it will not be possible to do this easily. Do not try to pry the materials out by inserting a knife or spatula into the space between the frame and

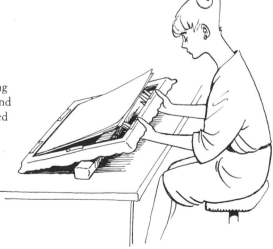

To unframe a work on paper that is a tight fit, begin by gradually pushing up one end of the glass and with it the layers of framed materials.

backboard. This can lead to severe damage and tears. If the layers are a tight fit, carefully push up one end of the glass from below to expose them. Place a weight or other object beneath the glass at the raised end so that the "package" remains on an incline. Gradually raise the entire "package," then grasp it on opposite sides and remove it from the frame to a prepared work surface, where the layers can be safely separated. For very large works of art, the operation should be carried out by two people. If the surface of the work is sticking to the glass, do not attempt to pry it off, but refer the problem to a conservator.

Labels removed from frame backboards are usually encapsulated or protected with Mylar, which is then attached to the new backing with nonbleeding pressure-sensitive tape.

BOOKS

Books should be treated as carefully as any work of art. They require the same general climate and light controls prescribed for works on paper, although the many other materials that make up a book—such as leather or parchment, cloth, glue, inks, pigments, and gold leaf—each respond in differing degrees to changes in atmospheric conditions. Books should never be stored in a damp environment; this will lead to deformation of the binding and to mold growth. Exposure to direct sunlight will cause leather, cloth, and decorated paper to discolor. A dry and polluted atmosphere will not only rot leather but will also desiccate the paper and the glue used in binding.

Books are particularly subject to mishandling. Bindings are frequently cracked along the spine in the attempt to make an open book lie flat. To reduce tension and prevent cracking, supports such as flat blocks, wedges, or another book should be placed beneath the open covers. If a book has a delicate binding that can be easily abraded, it should be laid on a felt cloth when in use. To turn a page, lift the top corner and lightly slip the fingertips down the fore edge, supporting the page. Never turn a page from the middle of the top, bottom, or fore edge. Never turn pages with

To prevent damage to the binding, place supports beneath the open covers of a book. To turn a page, lift the top corner and slip the fingertips down the fore edge.

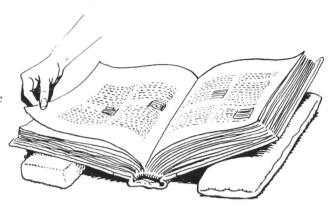

wet fingers or while holding a writing implement in either hand. Uncut pages or pages that are stuck together should be separated only by a conservator. Guard against small tears, brittle corners, and edges that can be further damaged by careless handling. To avoid stressing bindings or damaging brittle papers, rare books are not to be photocopied. All other library books should only be photocopied with the permission of the library staff.

When carried by hand, valuable books should be boxed or wrapped in glassine to avoid staining from skin oils. Groups of books should be transported on a wagon in a flat position, not on their fore edges.

Stacking and shelving

Do not stack open books, or place them face down, or put anything on top of them; the strain and extra weight will cause the bindings to crack. Never allow a book to stand on its fore edge. In this position the weight of the book forces it down, spreads the covers, and in so doing crushes the leaves and breaks the binding. Frail bindings should never be stacked. Heavy books should be laid on their sides, for in an upright position the text-block may sag; they must not, however, be stacked more than three or four deep.

Stand books on a shelf so that they provide comfortable support for one another. If books are shelved too loosely, their bindings will be strained; if too tightly, they can be damaged when pulled

from the shelf. When taking a book from its shelf, do not force it from the top or head of the spine; try to push back the books on either side and to clasp it around the middle of the spine. Lift the book, do not slide it off the shelf.

Valuable bindings should be boxed. Books with metal fittings that are not boxed should be separated from other books by 4-ply ragboard to protect the adjacent bindings from damage.

When a book is to be displayed open, strips of thin, flexible Mylar, which will not cut the paper, may be wrapped around the cover and the pages to be held back. The ends of the Mylar are usually fastened together with nonbleeding tape. Never use rubber bands or metal clips to hold book pages open; they will contribute to the disintegration of leather and will stain bindings and paper. If a reader wishes to mark several places in a book, thin, new, acid-free paper should be used for the purpose. Markers must not be inserted toward the spine, since this will place undue strain on it and could cause it to crack. In general, slips of paper should be removed from books to avoid cracking the spine and the migration of acidity onto the leaves. Extraneous material removed from books can be stored in archival-quality envelopes.

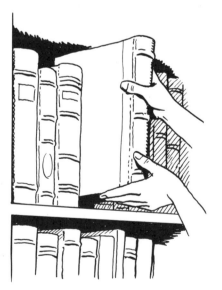

Stand books on shelves so that they support each other. To remove a book, clasp it around the middle of the spine and lift, do not slide it off the shelf.

Care and Handling of
Works on Paper and Books

1. Do not expose works of art on paper or books to unfiltered fluorescent lighting or daylight. For exhibition, maintain a light level of 5–8 footcandles (3–5 footcandles for damaged and/or vulnerable works). A three-month exhibition period should not be exceeded in any calendar year. This includes Museum and loan exhibitions. In storage, protect from all light.

2. Maintain 68°–72° F (20°–21° C) temperatures and 45–55 percent relative humidity.

3. Only ragboard and other high-quality acid-free materials are to come in contact with works of art on paper or with books.

4. Do not touch the surface of any work of art on paper.

5. Do not lift an unmounted print or drawing by the corners. Slide a sheet of ragboard or blotter beneath it and hold the support, not the work of art.

6. Protect prints, drawings, and books in transit and in storage by placing them in folders and using interleaving sheets.

7. Do not shuffle prints, drawings, or photographs, or attempt to pull an individual print or drawing from a pile without removing those above it.

8. Do not place pastels, charcoals, or miniatures face down.

9. Do not stack open books, stand a book on its fore edge, or shelve books too tightly.

10. Never use pressure-sensitive tape, metal clips, or materials containing rubber with works of art on paper or with books.

5. Far Eastern Works of Art on Silk and Paper

The mounting given to Far Eastern works of art on silk and paper is a significant factor in considering their conservation and handling. Most of these works have received some form of mounting during their history, both as a measure of protection and as a setting to enhance appreciation of them, and the condition of an individual piece depends greatly on how well it was mounted and on the present state of the mounting. Optimum conditions of light, clean air, temperature, and humidity will extend the life of a piece; it is from the juxtaposition of various materials in a mounting and the changing tensions among them that problems arise. Many aspects of a mounting are not visible from the outside, although each of its components and their arrangement have a delicate relation to the whole. It is for this reason that care in handling is always important even if the work and mounting appear sound.

SCROLLS

Scrolls, like many other Far Eastern art objects, are usually stored in boxes made to fit the individual piece. In China, these boxes were commonly made from varieties of rosewood, and in Japan from paulownia wood (*Paulownia tomentosa*). Substitutes can be found, but whenever possible it is preferable to use boxes of paulownia wood for storage. This extraordinary wood expands and contracts with changes in temperature and humidity but provides a stable environment in the interior of the box.

The special box in which a Far Eastern work of art is stored is of great importance to its preservation and frequently indicates its provenance. The practice since ancient times has been for a tea master, priest, or collector to write on a box authenticating the

origin of the object it contains or commenting on some aspect of the object's history. In China, Korea, and Japan, such notations enhance the value and aesthetic appreciation of the works to which they refer. Boxes should therefore be carefully preserved. The application of gummed tape and labels, or the pressure of ball-point pens or any other pointed instrument used for writing on them, will mar the surface permanently. These special boxes should not accompany objects to a loan exhibit unless they are to be exhibited themselves, in which case they should be registered as separate loans. They are made for storage, not shipping. With the object in its box, both may be easily damaged in transit, since their perfect fit leaves no room inside the box for packing materials.

Hanging scrolls

Before unrolling a hanging scroll, determine first whether or not it may be safely hung. The metal fittings for the cord on the outside (top) roller must be firmly affixed and the cord itself in condition to bear the suspended weight of the scroll. If the pole for hanging a scroll will be needed, have it at hand. If the scroll cannot be hung, choose a flat, clean surface on which to extend it.

There is the least chance of damage to a scroll when it is unrolled and rolled if the following rules are observed.

Unrolling

Hold the scroll in the left hand. Unwind the cord and lay the scroll on a table or another clean, flat surface.

Open the scroll to the bottom of the first section of the mounting or to the length of the free-hanging strips which may be part of the mounting.

Extend these strips.

If a pole is needed, the cord should now be inserted at its tip.

Grasp the lower roller in the left hand, thumb down, so that if the scroll slips from the top accidentally, it can be lowered without the risk of being creased by the fingers.

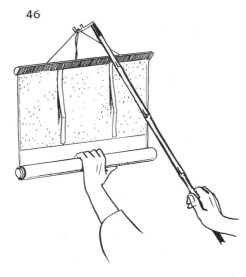

In unrolling a hanging scroll, grasp the center of the lower roller with the left hand, thumb down.

Move the scroll to the hook so that there is neither tension nor slack in the scroll.

Rest the pole. With both hands on the knobs of the bottom roller, lower the scroll to its full length slowly and evenly.

Rolling

Grasp the knobs of the bottom roller in both hands and roll gradually to eye level.

Insert the pole if needed.

Grasp the center of the bottom roller, thumb down.

To avoid creasing a scroll, rewind and secure the cord without using tension.

When viewing a handscroll (*facing page*), use a glass or wooden bar to hold it open. A handscroll should be opened and closed gradually and evenly, by one person at a time.

Remove the cord from the hook with the right hand, keeping the scroll even, without tension or slack.

Place the scroll on a clean, flat surface. Rest the pole.

Fold the strips and roll up to the top of the scroll.

Rewind the cord about the scroll, *without any tension*. Tension here will eventually cause creasing. (The illustration on page 46 shows the correct method for rewinding cord.)

Replace the scroll in its box with the outside roller toward the wide side of the "pillow" rest for the knobs.

Handscrolls

When a handscroll is opened, the cord and clasp should be secured in a clean cloth, soft paper, or similar material, to prevent possible damage and to keep them from getting in the way while the scroll is viewed. If the scroll is placed on a table for viewing and is not held in the hands, glass or wooden bars should be placed at either end to prevent its opening or falling accidentally. If necessary, such bars may also be used to hold the scroll open while it is viewed.

The scroll must not be tightly rolled. In the process of viewing, which entails unrolling the scroll to the left and rerolling it from

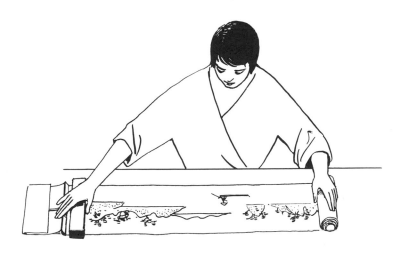

the right as sections are viewed, the roll on the right must be loose, never less in diameter than the scroll when fully rolled.

Opening and closing of a handscroll should be done gradually and evenly, by one person at a time to ensure that tension is equal on both sides.

Any deviation at top or bottom should be corrected as it is observed; if a spiral does occur, the scroll should be rolled back to where the deviation began. A scroll should never be forced into alignment by pressure of the fingers, which can easily soil or crease it. Rolled objects are most safely handled by a gentle but firm clasping of them in the palm of the hand, the fingers carefully surrounding them.

FOLDING SCREENS

A folding screen consists of an interior wooden latticework frame, paper hinges, papers variously layered, and an exterior frame, usually of wood. The work of art mounted on it may be bordered by decorative papers or silks.

A screen painting is conceived for the two, four, or six panels on which it is mounted. The integrity of the work is seriously affected if a hinge is broken or a panel becomes detached. Repair is difficult; the hinges are the first papers applied to the interior frames and are beneath many other layers of paper. Although temporary repairs can often be made, a single hinge cannot be properly mended except from the inside without losing the delicate balance between the panels.

The folds of a screen away from the viewer are the weakest, as they bear the greatest strain. The center panels should be opened first, then those to the left or right. In opening a screen, grasp the exterior frame with one hand at the side and the other at the top. The hand should form a V between thumb and fingers; pressure must be evenly applied and care taken that the fingertips do not press into the work or any part of the mounting.

Lacquerwork is easily scratched and special metal fittings are irre-

placeable. A screen must therefore rest on padded surfaces when being moved on a side truck and be padded wherever hard surfaces may come in contact with it. It can rest evenly on its short side, or on its long side with the folds of the reverse of the screen facing down. If a screen is to be moved any distance without a side truck, it should be carried by two people.

The condition of the interior of a screen cannot always be accurately judged from the outside. Care in the handling of these large, rather heavy objects is of the utmost importance.

Sondra Castile
Asian Art Conservation

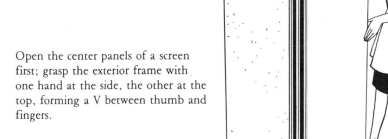

Open the center panels of a screen first; grasp the exterior frame with one hand at the side, the other at the top, forming a V between thumb and fingers.

Care and Handling of
Far Eastern Works of Art on Silk
and Paper

1. Maintain temperature at 68°–72° F (20°–21° C) and relative humidity at 45–55 percent. Light levels during storage or display should not exceed 5–8 footcandles.

2. When they are not on display, scrolls should be kept in their individual boxes. A scroll should be packed separately for transport, and the box itself treated as a work of art.

3. Do not attempt to hang a scroll without first checking that its condition makes it safe to do so.

4. Proceed carefully and evenly in unrolling and rolling scrolls, and apply no undue pressure or tension.

5. Open screens first by the center panels, then by one side panel at a time.

6. If moved by hand, a screen should be carried by two people; if a side truck is used, surfaces in contact with the screen must be padded.

6. Textiles

Because museum fabrics are, for the most part, made of organic material (fibers and dyes) they respond more critically to maintenance procedures and environment than do most works of art in other media. Their pliable and absorbent physical and chemical nature makes fabrics very sensitive to degradation during handling, storage, study, and display. Deterioration of objects made of fiber progresses at all times and can easily be hastened by negligence, mishandling, climate, contaminants, and light. Deterioration can, however, be significantly slowed—and preservation of the present state enhanced—if fabric is provided with an optimum environment in exhibition galleries and storage areas and while it is being transported and studied.

Atmosphere

Steady temperature and relative humidity levels are important for preserving organic material. Sudden changes as well as extremes in either one are damaging to fabrics. Acceptable ranges for a fabric collection are a relative humidity of 50 percent plus or minus 5 percent and a temperature of 68°–72° F (20°–21° C). The temperature can be adjusted as long as the relative humidity is maintained at a particular level throughout the year. Other factors must also be considered. For instance, a very warm environment can encourage desiccation of fabric, and if the relative humidity goes over 70 percent, fungus growth may occur.

It is essential to provide a stable climate, particularly in the storeroom where a fabric collection will remain for most of its life. This area must be kept clean and air-conditioned. Slight but steady circulation of air should be maintained: stagnant air in any part of a room or storage unit increases fiber deterioration and may attract insects; drafts, on the other hand, may blow in damaging airborne dust.

Illumination

All light causes photochemical degradation of fibers and dyes, and museum fabrics can be adversely affected even by seemingly normal use of artificial light. Ultraviolet and infrared rays (both are emitted by sunlight, UV by fluorescent light, and IR by incandescent lighting) are particularly harmful. Visible light also harms fabric and dyes; direct sunlight, therefore, should not come into textile exhibition or storage areas. Any windows that exist must be ultraviolet-filtered, and draped to prevent the entry of unnecessary light, as well as heat and dust. Light bulbs and fixtures should be properly positioned and lights turned on for as few hours as possible to reduce the amount of heat and light emitted.

In order to protect fabrics from photochemical damage, such as fading and embrittlement, it is essential to keep a fabric collection in darkness as much as possible and to control the use of light in the storeroom, study room, and exhibition galleries. Photochemical damage caused by the ordinary use of light in the course of a year or two is not easy to discern with the eyes. Once inflicted, the damage cannot be reversed, but it is possible to slow down further degradation by restricting levels of illumination and exhibition periods. Five to 8 footcandles of light and an exhibition time of no more than three months per calendar year are recommended for museum fabrics.

Lighting for photography causes considerable damage to fabrics. If a fabric is to be photographed, do it once; repeat photography must be avoided not only because of the harm it causes, but also because it necessitates mechanical handling and changes in temperature and relative humidity. Flash bulbs should not be used.

Storage and handling

In addition to climatic fluctuations, photo-oxidation, and air pollution, there are other environmental causes of chemical damage. Rooms where museum fabrics are kept must be clean, and materials for surfaces that come into contact with museum fabrics should be properly selected, prepared, and kept clean.

Clean hands are essential. It cannot be emphasized too strongly that immediately before handling fabrics and after every interruption, hands should be washed and completely dried.

The worktable is another surface with which museum fabrics come in contact. Because of their nonabsorbent nature, hard surfaces such as wood, formica, and glass collect grime, which will be transferred to fabrics placed upon them unless preventive measures are taken. The worktable should therefore be covered with cotton padding with a sheet of desized muslin stretched over it; another sheet of muslin should be placed on top and changed daily (muslin will pick up grime that would otherwise be transferred to the fabric).

Mechanical damage from abrasion, tension, and vibration can be caused by the cumulative effects of the simple motions that occur during routine actions such as pulling, dragging, stretching, folding, and rubbing. Museum fabrics should, therefore, be handled as little as possible, and when handled, touched as little as possible. To this effect, museum fabric must always be placed on a supporting sheet of acid-free paper or cardboard. This gives stability to the fabric and permits the support, not the object, to be moved. If it is necessary to touch the fabric, it should be with as little manipulation as possible.

Good preparation for storage is the key to good preservation, and should be done only by a responsible, trained person. While in storage, fabrics should be in direct contact only with chemically inert and physically suitable storing materials such as acid-free paper or properly treated unbleached muslin. Acid-free tissue paper should be commercially buffered and, preferably, made of fiber instead of wood pulp. Muslin should be washed to remove starch sizing and other undesirable matter before use; if it has been commercially dry-cleaned, it should be rewashed to assure that all residual cleaning agents have been removed. To decide whether paper or muslin should be used for storage purposes, one should consider both the characteristics of the museum fabric to be stored and the environmental situation.

The fabrics in a storage unit must be arranged for easy access. Each fabric should be prepared independently and uniformly so

that when one fabric has to be taken out, others need not be touched, thus reducing handling and the chances of accidents. The location of each stored fabric should be indicated in a card file, the accession number of each piece should be clearly written on the package (in the same position on all packages), and each package should be easily located.

If the museum fabric is resilient enough to tolerate bending, it can be rolled. Fabric must be rolled without creating creases, ridges, or undue tension. This is a difficult operation and two or three people may be required to perform it successfully. Use the padded worktable and roll the fabric over a tube covered with desized muslin or acid-free paper—the diameter of the tube is determined by the condition and thickness of the fabric. Generally, the fabric should be rolled in the direction of the warp with the right side in.

Folding should be avoided wherever possible, as it causes fibers to weaken and break along the folds. If it is unavoidable, acid-free tissue paper should be crushed and placed in the folds. Never allow a sharp crease.

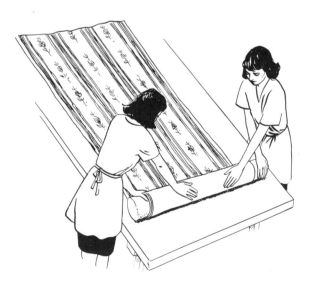

Roll fabric over a tube covered with desized muslin or acid-free paper; roll carefully without creating creases, ridges, or undue tension.

If polyethylene film is used as an exterior covering, a layer of acid-free paper or muslin should be placed between it and the fabric. Any film covering should be left unsealed to avoid condensation and should be changed frequently because its static electricity attracts dust. The accession number should be clearly written on outside wrappings. A card and/or photograph may be added for additional identification.

In handling fabrics, avoid any motion or vibration whatsoever by supporting the object on a solid surface, such as acid-free cardboard, and covering it for protection against moving air. If a fabric has been mounted permanently by having been sewn onto a stretcher, the mount should be covered with a Plexiglas box, encased in a blackout cover, and stored flat. For temporary storage, an unmounted fabric may be placed on a solid board that has been covered with a buffered paper, such as glassine, and laid, but not stacked, in a drawer. The drawer must be pulled in and out gently so as not to cause vibration and movement of air.

Insecticides

The fumes of insecticides in common use, such as paradichlorobenzene and naphthalene, are heavier than air. The insecticides will not, therefore, be effective for anything located above them, and should be placed at a level higher than the fabrics to be protected. They should be wrapped in an open-weave cloth and never placed in contact with the fabrics themselves. Objects made of leather, skin, fur, wax, feathers, and resins can be adversely affected by volatile insecticides and should be stored separately. Ethylene oxide fumigation is highly toxic to people and objects, and it may affect certain natural dyes. This treatment should therefore be undertaken only on the advice of the conservator, and then with utmost caution.

Transport

Museum fabrics in transit must be covered and supplied with a rigid support. The support may be a flat board, a box, or a tube

that either is made of inert material or has been given an acid-free barrier as a protective layer. Hold the support, not the fabric, and carry it horizontally. The truck or dolly used for transport should be equipped with swiveling, rubber-covered casters and with shock absorbers. Secure fabrics on the truck and move it slowly. If the fabric is to be carried by hand, it must be placed in a box or case; a fabric should never be carried exposed or hanging free.

Adapted, with permission, from an article by Nobuko Kajitani, Textile Conservator: "Care of Fabrics in the Museum," in *Preservation of Paper and Textiles of Historic and Artistic Value,* ed. John C. Williams, Advances in Chemistry Series No. 164, pp. 161–180. Copyright 1977 American Chemical Society

Care and Handling of
Textiles

1. Maintain temperature at 68°–72° F (20°–21° C) and relative humidity at 45–55 percent. Control the amount and type of light in storage, study, and display areas.

2. Hands must be washed and dried before handling textiles.

3. Use only chemically inert materials in contact with fabrics.

4. Worktables should be covered with clean desized muslin that is changed each day.

5. Handle fabrics as little as possible; support them on a solid surface when examining or transporting them.

6. To avoid damage, fabrics in storage should be easily accessible, clearly identified, and protected from light.

7. Avoid folding fabrics.

8. If plastic wrapping is used, an inner covering of acid-free tissue must be provided.

7. Costumes

The materials encountered in a costume collection are vast in scope, frequently combining in one garment a variety of organic and inorganic substances. Like all textiles in a museum collection, costumes are readily susceptible to color and fabric deterioration due to excessive light, fluctuations in climate, and atmospheric pollution, and to physical stress or breakdown due to the varying weight of the different materials that compose them (and of course most have been weakened by wear and exposure to light). Unlike the vast majority of textiles, however, which are displayed as flat, two-dimensional works, costumes are meant to be viewed from all sides. Because they are often fragile, not of rigid construction, and frequently large and unwieldy, costumes have to be supported internally and externally for both display and storage.

Lighting, temperature, and humidity

Costumes, like other art objects, need a scrupulously clean environment; the air must be filtered and the surfaces with which the costumes come in contact must be dust-free and smooth. Since all types of lighting are potentially harmful, filtering of natural and fluorescent sources of light is essential. The heat from tungsten lamps must not be allowed to build up; light levels should not exceed 8 footcandles, particularly for exhibitions running longer than three months. In storage, closets fitted with venetian blinds, rather than doors, serve to shield light and dust from the clothing while permitting air circulation. Adequate ventilation should be ensured by means of small openings or holes in the backs of cabinets and drawers and by allowing air space below. The temperature should be maintained in the range of 68°–72° F (20°–21° C) and the relative humidity at approximately 50 percent. If atmospheric conditions are not centrally controlled, baffled humidifiers, dehumidifiers, or fans should be used in galleries requiring them. Before any costume or accessory that is suspected of infestation goes into stor-

age, it must be fumigated. The conservator should determine which fumigant is to be used and how long a garment should be aired after it has been treated.

Storage

Storage must be adapted to the object; the decision to hang it or lay it flat, to brace it from the exterior or support it internally with stuffing, depends upon its condition, points of stress, and tension, and should be made by the curator or conservator. It is essential that storage areas provide an ample amount of space around each garment. There should be closets to allow costumes of sturdy construction to hang, and drawers in which those that are fragile, very heavy, or otherwise exceptional in construction can lie flat. When stored in drawers, the heavier garments or accessories should be placed at the bottom, with lighter ones above (brittle silks, heavily starched garments, and feathers are easily damaged and should therefore always be placed above other materials). In preparing garments for flat storage, make as few folds as possible and cushion these folds with acid-free tissue; the garments should be taken out periodically and the folds changed. Plastic boxes and trays are useful for storing small items such as shoes and stockings.

Anything that comes in contact with costumes or accessories, including closet, shelf, drawer, and box linings, should be of acid-free material; cotton and linen fabrics left in direct contact with detrimental vapors or acidity coming from untreated material will eventually turn yellow. Acid-free tissue paper has multiple uses: it is laid flat between garments in drawers, made into padding for folds, pleated accordion fashion as dividers between closed fans, crushed to fill sleeves or shoes. Other materials, such as plastic hangers and rigid materials used for supports, must also be inert. Stiffened Mylar wrapped in acid-free tissue is used for hat cones or shoe supports. Tissue padding between the plastic support and the object protects against dust that may be attracted to the plastic, prevents bruising of the object, and allows the weight to be evenly distributed. When plastic is not available, clean, unbleached, unstarched cotton and acid-free ragboard can be substituted. If

closets are not available, hanging garments should be covered with cotton and then with black polyethylene sheeting as a light shield; to allow air to circulate and to minimize problems of condensation, the polyethylene should not be sealed. Pins used with costumes must be of brass or stainless steel only; those that have fallen to the floor should never be reused, since the dust that adheres to them will stain the fabric. Do not write accession numbers directly on a garment; use indelible, nonbleeding ink on linen (Holland) tape, and sew this to the inside of the garment with unwaxed cotton thread. For easier viewing in storage, accession numbers may also be written on paper tags to be attached to the costume with cotton thread and brass pins.

Handling

Costumes and accessories should never be tried on, and should be handled only by authorized persons. To ensure a minimal amount of handling, ample space to allow for visibility in storage and careful organization of the collection are both essential. Garments hanging in closets should never be tugged or pulled; they may have to be provided with extra loops for hanging if stress points are likely to develop. Costumes should be cradled as they are removed from racks: distribute the weight evenly by holding

When carrying a costume, distribute its weight evenly by holding the hanger in one hand and supporting the garment with the other.

the hanger in one hand and supporting the garment with the other; do not attempt to smooth out the garment at this time—avoiding any strain on it is more important.

The most dangerous period of physical stress for a costume is when it is placed on a mannequin. The mannequin must be made to fit the dress and not vice versa. Never pin or stitch folds in a garment to make it smaller, or stretch it to fit the model; instead, use a smaller mannequin and pad it where needed. Two people should always dress a mannequin; a drop cloth should be placed on the floor in the work area and a table provided nearby to hold the costume and the stuffing materials.

Examination tables must be large enough to support the entire garment. The surfaces should be smooth and covered with clean, unbleached cotton or good-quality ragboard, and all sharp objects and pins must be removed. When costumes are examined by students or visitors, a curator or authorized person must always be present to handle them. Measurements may be taken in order to copy a garment, but rubbings and photocopying are not allowed because of the handling they involve. Only pencils are to be used for making notes.

Only a knowledgeable and responsible person should undertake costume repair. All original parts must be retained, and repairs made in such a way that they can be removed without damage to the original. Do not wash, dry-clean, steam, or iron a costume without the advice of an expert.

Transport

When large garments or a group of garments that are sturdy are to be moved from one location to another, they should be placed on a rack without crowding. Two people should move a rack so that the clothing on it does not sway. When a rack is used, the garments should be covered by a cotton sheet for protection. The base of the rack should be covered with cotton to prevent snagging and dust collecting. Costumes that are too fragile to hang and small objects should be carried in trays or boxes, protected by a covering of tissue paper or cotton.

Care and Handling of Costumes

1. Protect costumes from excessive heat and light when they are on display or in storage.

2. Hands must be clean and dry. Wash them before starting work and whenever they are warm, perspiring, or soiled.

3. Do not wear rings, bracelets, or any kind of jewelry that could possibly catch in a costume and rip or snag it.

4. Never open or close a storage drawer quickly.

5. Check all tissue paper and wrapping materials carefully before discarding.

6. Use only stainless steel or brass pins. Do not use pins that have fallen on the floor.

7. Never try anything on.

8. Only a knowledgeable person should undertake costume repair. Never take away, trim, or cut any original fabric that is part of a costume.

9. Do not use solvents, spot removers, or erasers on costumes.

10. Never use an iron or steamer without permission.

11. Do not use pressure-sensitive tapes, glues, or bonding materials on costumes.

12. Two people should move costumes on racks and dress and undress mannequins.

13. When carrying costumes by hand, be sure they are well supported and not straining or dragging.

14. Use only pencils for taking notes.

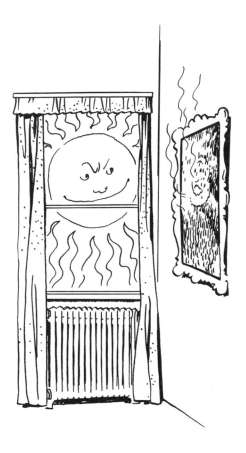

PART II

1. Lighting

All light, particularly that in the ultraviolet (UV) and infrared (IR) regions of the spectrum, induces chemical change, which ages materials by degrading them. The most pernicious photochemical damage is caused by UV rays (below 400 nanometers). IR radiation will cause chemical changes due to the effects of heat, and it accelerates the destructive effects of both UV and visible radiation. Visible radiation, though not as profound in its destructive capacity as IR or UV, can cause fading or darkening of some pigments, lakes, and dyes. Photochemical deterioration, which occurs in organic objects such as works on paper, textiles, and ethnographic material, is cumulative and cannot be reversed. It appears in many ways, including physical and structural changes such as embrittlement, degradation of synthetic and natural materials, oxidation of varnishes and certain pigments, and bleaching, discoloration, yellowing, and darkening of paper, textiles, and woods.

The damage to an object from exposure to light is proportional to the intensity of illumination it receives multiplied by the duration of exposure; in other words, an object exposed to 10 footcandles (a relatively low level of light) for 100 hours will suffer the same deleterious effects of radiation as an object exposed to 1,000 footcandles for only 1 hour. Unless an object is contained in an environment of inert gas and in darkness, it is impossible to prevent natural aging. Effective measures can, however, be taken to retard it.

1. Control spectral distribution of light.
 UV-absorbing acrylic sheeting, such as UF-4 Plexiglas or Lucite SAR 1104, should be used for glazing textiles and works on paper whose surfaces are stable, for vitrines and windows, and, in sleeve or tube form, for shielding fluorescent lamps (unfiltered fluorescent light emits high levels of damaging shortwave UV radiation). UF-3 Plexiglas (or comparable material) filters out most UV radiation; UF-4 Plexiglas has somewhat lower absorption. The former has a slight yellow cast; the latter is clear. UV filters made of polyester film with a reflective silver coating for use on fluorescent tubes offer greater protection from UV and visible radiation, especially for natural dyes, and do not significantly alter the amount or color of light available for viewing. Because of its electrostatic charge, plastic sheeting must never be used with paint that is in danger of flaking or with powdery surfaces such as pastels, chalks, loosely attached charcoal, and gouache (see Part I, 4).

2. Keep light levels low.
 Light levels in galleries containing organic materials should be kept as low as possible, and *should not exceed 8 footcandles*. For paintings, special restrictions are not normally required; however, for mixed-media paintings or those with particular problems, the conservator should be consulted. If the light in adjacent galleries or access areas is maintained at a reasonably low level, the eye will adapt to subdued illumination.

3. Limit exposure times.
 a) Sensitive objects should be displayed in rotation and should not remain on exhibit for indefinite periods. Organic materials must not be displayed for more than three months a year.
 b) When not in use, gallery and storage areas housing light-sensitive organic materials should be darkened and window curtains or blinds drawn.

c) Framed prints, drawings, and textiles when in storage should be covered with kraft paper, blotters, or dark fabric.

4. Maintain specified humidity and temperature conditions at all times (see Table 2). Photochemical reactions are accelerated by excessive heat and moisture.

5. Avoid exposure to direct or reflected sunlight, and heat build-up from spotlights.

6. Monitor light levels with a footcandle meter and UV monitor when exhibitions are installed, and periodically thereafter.

Table 1. ILLUMINATION

Types of Material	Recommended Light Level ALL LIGHT IS TO BE ULTRAVIOLET-FILTERED
HIGHLY SENSITIVE MATERIALS Organic materials: textiles, costumes, carpets, art on paper, photographs, books, wallpaper, dyed leather, parchment, lacquerware, basketry, fibers used in ethnographic objects, feathers, some woods (painted and unpainted), lakes, dyes, some pigments, miniatures	5–8 footcandles; 3–5 footcandles for damaged or highly vulnerable materials. Exhibition not to exceed a total of 3 months in any calendar year (including loan and in-house exhibitions). Storage in darkness.
Organic materials combined with light-insensitive materials	Exposure level appropriate for light-sensitive components.
Insensitive materials restored with light-sensitive components, such as pigments, adhesives	Special restrictions not normally required. When in doubt, consult conservator. Guard against heat buildup from spotlights and direct sunlight falling on paintings.
MODERATELY SENSITIVE MATERIALS Oil paintings on canvas, panel paintings, acrylics on canvas	Consult conservator.
Undyed leathers, horn, ivory, bone, some woods	
INSENSITIVE MATERIALS Metals, ceramics without over-painting, glass, jewelry, enamels, unpainted stone	Special restrictions not normally required.

2. Relative Humidity and Temperature

Relative humidity (RH) and temperature in gallery and storage areas must be maintained at constant and appropriate levels to ensure the chemical and dimensional stability of organic and inorganic art objects. Each object has individual RH requirements, based on such factors as its components, thickness, extent of deterioration, its equilibrium moisture content (the amount of moisture it characteristically absorbs and releases in relation to the atmosphere), and its previous environment. Excessive dampness, dryness, or heat, and fluctuations in RH and temperature, will have a detrimental effect on an object. Dimensional changes, chemical reactions, and biodeterioration will occur under adverse circumstances (see Table 3).

1. Keep RH levels constant at all times. Temperature must be maintained within reasonable limits, approximately 68°–72° F (20°–21° C). Extremes of temperature will result in excessively damp or excessively dry conditions.

2. In storage and exhibition areas, maintain the environmental conditions to which the object is acclimated. The same conditions are required when the object is on loan to another institution.

3. Air-condition storage and display areas in order to maintain proper RH levels and to aid in the removal of gaseous pollutants and dust. Circulate air to prevent the growth of mold and mildew.

4. Do not display any art object near sources of heat such as radiators, in direct sunlight, or under excessive incandescent illumination such as spot lamps. The heat generated from such

sources will lower the RH in the surrounding atmosphere, endangering the object by causing it to lose moisture.

5. Monitor RH in showcases and/or galleries with recording hygrothermographs, dial or liquid-crystal hygrometers, or RH indicator cards. Dial and recording hygrometers should be checked for accuracy on a six-monthly basis with a wet-and-dry-bulb hygrometer.

6. In order to maintain optimal stable conditions, display and store objects that are extremely sensitive to moisture in individually controlled cases (micro-environments), such as a vitrine, using buffers or silica gel equilibrated to the proper RH.

7. Consult the conservator about the appropriate conditions for any problematic object, and whenever organic and inorganic materials are to be displayed together.

Because each art object has individual RH requirements, Table 2 (overleaf) is intended only as a general guide, offering approximate target levels. Stability of RH is more critical than the absolute value.

Table 2 overleaf

Table 2. RELATIVE HUMIDITY (RH)

Types of Material	RH	Special Considerations
ORGANIC MATERIALS Paper, parchment, leather, textiles, horn, ivory, bone, feathers, reeding, gourds, bark, adhesives (natural and synthetic), wood, polychrome sculpture, panel and canvas paintings	45–55%	RH above 65% leads to mold growth on some materials, RH below 40% to embrittlement.
Chinese paintings, lacquerware	55–60%	
INORGANIC MATERIALS Stable metals, enamels Stone, ceramics, glass	30–60%	Consult conservator.
INORGANIC MATERIALS WITH SPECIAL PROBLEMS Devitrified, weeping, and crizzling glass, bronze-diseased objects, unstable metals (rusty iron, etc.), ceramics and stone with embedded salts	30–45%	In general, RH to be as low as is practical, but some objects in this category require higher humidity.
ORGANIC AND INORGANIC MATERIALS COMBINED Objects and exhibitions with both types of components	45–55%	RH to be governed by the most sensitive component—consult conservator.
Inorganic objects, such as ceramics and glass, restored with organic adhesives and moisture-sensitive materials	30–45%	

3. Photography

The same caution that is exercised in determining light levels in a gallery is required in photographic procedures. The amount of intense heat to which an art object may be subjected in photography is as much a matter of concern as its exposure to light while on display. As objects vary in their sensitivity to UV light and visible light, they also differ in their responses to heat, depending on their components, thickness, conductivity, and color. The cycle of heating and cooling that an object may be forced to endure when photographed is detrimental to both organic and inorganic materials, especially if this cycle is repeated many times. Stress is engendered by the concentration of absorbed heat on one side of the object and the resultant drop in RH and increase in temperature. Prolonged periods of exposure are particularly dangerous, since an increase in temperature increases the probability and rate of a chemical reaction in the object.

In sensitive materials, excessive or prolonged heat radiation from photographic lamps will cause such problems as desiccation, warping, shrinkage, cracking, flaking, softening of waxes, attraction of dust, weakening of adhesive bonds, and the breakdown of textile and paper fibers. Excessive heat may result in bulges and distortions in wax-lined canvas paintings. Such paintings, as well as panel paintings, are subject to pinpoint flaking as a consequence of overheating, a problem which may not become visible for six months following exposure to photographic lamps without heat filters.

General precautions

Because of the cumulative damage due to the effects of light and heat, objects that are known or suspected to be fugitive in color or otherwise sensitive to heat and light should not be repeatedly photographed. When such objects are photographed, efforts

should be made whenever possible to turn the lamps off at intervals following a maximum three-minute setup period at 100 footcandles, or to dim the lights at noncritical moments. Lights should always be kept at a safe distance (i.e., far enough away to prevent more than a 5° F temperature increase on the surface of the object). As additional protection from unnecessary exposure, the light level should be established, and the appropriate shutter speed and aperture opening determined, as soon as possible after the object is set in place and illuminated. For objects that are extremely vulnerable, the use of existing transparencies, photographs, and reproductions (particularly for television work) should be encouraged.

Filtering light

Since the damaging UV and IR portions of the spectrum do not contribute to visibility, the use of UV- and IR-absorbing filters on photographic lamps—to protect the object from photochemical and heat deterioration—will not reduce the amount of light the photographer has available. (In some instances, it may be necessary to use a light-balancing or color-compensation filter on the camera lens to correct any color shift resulting from the use of absorbing filters on lamps.)

Tungsten and quartz lamps, the types employed most frequently in the photography of art objects, produce little UV but emit high levels of IR. To guard against damage, therefore, heatsensitive objects should not be exposed to photoflood or spot lamps unless these lamps are filtered with IR-absorbing glass. When available, the safest lighting for photographing vulnerable material is considered to be electronic flash (strobe). Although the instantaneous flash from strobe emits high levels of UV and IR, the duration of exposure is so brief as to be not unduly injurious. Most modern units incorporate UV-absorbing glass; without this, a filter UF-3 Plexiglas should be employed. Among the advantages of strobe lighting are greater color accuracy and image sharpness.

When objects are to be exposed to prolonged or intense lighting, as in film or television work, or when especially sensitive objects such as panel paintings are photographed, an HMI lamp is recom-

mended. This lamp generates comparatively little heat but is rich in UV, and therefore requires the appropriate filtering.

It should be assumed for safety's sake that no object in the museum is immune to the damaging effects of heat and light.

Handling

1. Problematic or fragile objects sent to the Photograph Studio should be accompanied by specific instructions for their handling, and if necessary by a curator or departmental technician assigned to handle them.

2. To protect works of art and minimize their handling while in the Photograph Studio, curatorial departments should provide storage trays for objects, and solander boxes for works on paper.

3. To avoid unnecessary retakes and handling, an order for special photography should be accompanied by specific instructions as to angle, lighting, details required, and so on. In many cases, the person responsible for the order should also be present during the photography session.

4. An object that has to be propped up or otherwise secured should be handled and positioned only by persons familiar with that type of object, and the curator and photographer must decide between them on the most suitable means of support.

5. Before positioning an object, secure the surface upon which it is to rest and the background material.

6. Whenever possible, move the camera and not the object to attain the proper angle and focus.

7. Never adjust the camera lens directly over the object.

8. Wear clean cotton gloves to handle metal objects unless otherwise advised by the conservator or curator.

Lighting

1. a) For heat- and/or light-sensitive objects, including all organic material, IR- and/or UV-absorbing filters are to be used on photographic lamps.
 b) For objects that are light sensitive, use when possible electronic flash (strobe) in preference to photofloods or spot lamps. Depending upon the object, strobe and modeling lights may need to be filtered (if they are not so equipped) to absorb UV radiation shorter than 380 nanometers. An alternative method is to shield the object with UV-filtering acrylic sheeting.
 c) For objects that cannot withstand heat, IR-absorbing glass is to be used on tungsten, halogen quartz, and other incandescent photographic lamps. For panel paintings with pinpoint flaking, for other objects that can be damaged by even slight heat, and for television filming, HMI lamps are recommended, UV-filtered when necessary.

2. Maintain light intensity as low as possible. For extremely sensitive objects use indirect lighting: bounce light off adjacent white surfaces, or diffuse it through tissue or other material.

3. To prevent heat buildup when an object is heat or light sensitive, lights should be turned off, or away from the object, at intervals following 3-minute periods at 100 footcandles. Keep lights off when not in actual use. Turn them on only for focusing, for light readings, and for shooting, at which time they can be brought up to full intensity and color temperature by using a rheostat.

4. To reduce heating effects and minimize danger from accidents, keep lights at as great a distance as possible from the object being photographed and from neighboring art objects. The surface temperature of the object should not rise more than 5° F.

5. Use fan-cooled lamps, if available, which will help prevent objects' heating up under strong illumination.

Environment

1. Maintain conditions of temperature and RH consistent with Museum exhibition and storage areas. Air-condition and control humidity in rooms where photography takes place. If the conditions in the Photograph Studio are unfavorable for a particular object, the curator or conservator should designate a more suitable location.

2. For heat-sensitive objects, monitor the surrounding location with a dial or liquid-crystal hygrometer or hygrothermograph, so that lights can be shut down if there is a sharp rise in temperature.

Photographers under contract

1. Every department engaging an outside photographer should be informed of the type of lighting the photographer proposes to use and should make sure that Museum guidelines are followed.

2. It is recommended that television and film crews use HMI lamps. HMI lamps are often required when sensitive materials are being photographed; the conservator or curator should determine whether or not they are to be used.

3. The curator and/or conservator concerned should notify the department engaging an outside photographer of any special lighting restrictions applicable to the object or area being photographed.

4. To ensure compliance with Museum standards, a person designated by the curatorial and/or conservation department concerned should be present when objects are photographed by a photographer under contract.

Visitors to the Museum

1. Flash apparatus, video cameras, and modular telephones are not permitted in any area of the Museum. Any exceptions must be approved by the Public Information Office.

2. Photography is permitted in the permanent galleries, but not in special exhibitions displaying objects not owned by the Museum.

3. Tripods may only be used by special permission. Inquiries for passes should be directed to the Information Desk.

4. Environment and the Deterioration of Art Objects

Deterioration is a continuing process, the result of a series of chemical and physical reactions which are often provoked by more than one environmental factor. Table 3 (pp. 78–81) tabulates the main causes of deterioration and gives examples of its effects. Physical and chemical changes are frequently interrelated and both are accelerated by light and moisture. Objects are best protected by maintaining stable levels of relative humidity and temperature and appropriate light levels (see Part II, 1 and 2).

Table 3 overleaf

Table 3. ENVIRONMENTAL FACTORS CONTRIBUTING TO THE DETERIORATION OF ART OBJECTS

Environmental Factor	Chemical Reactions
Excessive humidity	Corrosion and tarnishing of metals
	Efflorescence of salts in stone, ceramics, and glass
	Decomposition of cellulose and proteinaceous materials, such as paper, parchment, leather, textiles, adhesives (vegetable and animal)
	Fading of color dyes in photographs and transparencies
	Migration of impurities, and staining in organic objects
Excessive dryness	Embrittlement, desiccation, and shrinkage of organic materials due to dehydration (e.g., collapse of cellular structure and rupture of fibers in paper, textiles, leather)
Excessive heat (due to high ambient temperature from radiators, sunlight, incandescent light, spotlights, photo flood lamps)	Acceleration of aging and desiccation of organic materials due increased rate of chemical reactions
Light Visible and ultraviolet below 400 nm	Photochemical and oxidative reactions such as color changes and structural breakdown in organic materials
	In visible light: fading of fugitive dyes, bleaching of wool and paper; color changes in some organic pigments
	In UV light: yellowing of silk and paper, bleaching of paper, oxidation of lacquerware surfaces, darkening of some light woods, fading of some dark woods, discoloration of some natural and synthetic resins, breakdown of cellulose and proteinaceous materials

imensional and Other Physical Changes	Biodeterioration
hanges in size and shape of hygroscopic materials (paper, parchment, leather, textiles, wood, ivory, reeding) due to absorption of moisture, such as swelling, expansion, warping, splitting, cracking, softening (e.g., tightening of canvas, cockling of paper)	Mold growth, mildew, fungus, dry rot
xpansion of different materials at different rates, causing damage in objects made of more than one type of material	Encouragement of certain types of insect activity
hanges in size and shape due to dehydration (e.g., drying out of adhesives, detachment of veneers, cracking of book bindings, slackening of canvas, warping of wood)	
oftening of resins, waxes, gums, with consequent attraction of dust istortion and bulging of wax-lined canvas paintings inpoint flaking of panel and canvas paintings plitting and warping of wood due to dehydration	
hysical breakdown, such as embrittlement, of organic materials as a result of chemical reactions catalyzed by light	

Table 3 continued overleaf

Table 3 continued

Environmental Factor	Chemical Reactions
Atmospheric pollution Sulfur dioxide Nitrogen oxides Ozone	Corrosion of metals, including iron, steel, and some bronze alloys Deterioration of some materials containing carbonates, such as marble, limestone, and frescoes Color reactions such as bleaching of synthetic dyes Degradation of cellulose and proteinaceous material and many synthetics
Hydrogen sulfide	Tarnishing of silver Blackening of lead pigments such as lead white and red lead
Soot and dust	Staining in organic materials due to acid migration
Proximity to detrimental materials Organic acids from wooden storage cabinets	Corrosion of metals such as copper alloys, bronze, lead, and zinc, sometimes in conjunction with bronze disease Colored spotting on black-and-white silver photographs
Sulfur vapors from rubber-based products	Tarnishing of silver objects; staining and deterioration of cellulose materials
Wood and wood-pulp materials	Migration of acidity leading to weakening and discoloration (e.g., browning of paper)
Skin oils and salts	Etching of metals; staining of organic materials such as leather and paper

Dimensional and Other Physical Changes	Biodeterioration
Weakening of structure and loss of strength in materials as a consequence of chemical deterioration (e.g., loss of detail in marble and limestone statuary, loss of strength due to fiber breakdown in paper and textiles, powdering of leather)	
Soiling and discoloration of surfaces	Encouragement of certain types of mold growth
Loss of tensile strength in organic materials	Encouragement of certain types of mold growth

5. Museum Loans

Art objects are subject to risk each time they are moved, handled, transported, exposed to variations in atmospheric conditions, or subjected to prolonged or excessive light. In order to ensure the optimum state of preservation, the same conditions required in the Museum must be adhered to when objects are exhibited at a borrowing institution.

Preloan checks

Museum loan regulations require that objects be in suitable condition for travel. This is determined by the curator in consultation with the conservator prior to the curator's official recommendation of the loan. The conservator should indicate on the appropriate forms that the object has been seen and approved for loan. In certain instances a full condition report, documented by photographs, may be desirable.

Loan criteria

The following factors should be taken into consideration in determining loan recommendations:

1. Danger to the object because of fragility (in structure or composition) or because its deterioration has left it vulnerable to climatic changes, light exposure, or vibration and movement.

2. Size and weight of the object. Packing and/or shipping problems will be created if it is very large or very heavy.

3. Climatic and lighting conditions at the borrowing institution.

4. Duration and type of loan. A long-term or traveling exhibition can subject sensitive material to excessive light exposure or the hazards resulting from repeated packing and unpacking.

Conditions of agreement

Objects are lent only to institutions whose safety and conditions of atmosphere control are known to the Museum. Loan agreements are based on the borrower's undertaking that it will respect the Metropolitan Museum's specifications regarding humidity and temperature levels, lighting, security, fire protection, and display requirements, that the objects will not be unframed or dismantled, and that all damages will be reported to the Museum immediately. Specific questions regarding the Museum's conditions governing the loan of objects should be directed to the Loans Office.

It is the responsibility of the curatorial departments and their conservators to specify care and handling instructions, such as what lighting levels are required, how very small objects are to be secured to wall or vitrine, and whether particularly light-sensitive objects may or may not be photographed while on loan. This information is to be typed on the loan form.

Loan renewals

Renewal of long-term loans is done annually so that the curator may decide if the loan is to be continued. Among the factors to be taken into account is the likely damage to an object from prolonged light exposure or unfavorable atmospheric conditions.

Couriers

In addition to accompanying loans and ensuring their proper handling in transit, couriers may have the responsibility of observing their installation at the borrowing institution, as well as their unpacking and packing. Couriers who are present at the installation of loan exhibitions should be aware of light levels and other conditions specified by the Museum, and should ensure that these are respected.

6. Selected Glossary

Acrylic sheeting: Ultraviolet (UV)-filtering plastic

Ultraviolet light, which is the portion of the spectrum most damaging to works of art, may be effectively filtered out by the use of UV-absorbing plastic. This type of polymethyl methacrylate or acrylic sheeting is employed for glazing framed pictures, windows, and display cases, and as sleeves to cover fluorescent tubes. When used as a glazing medium, it should be separated from the work of art by a space of at least ⅛ inch. Acrylic sheeting readily attracts dust; before it is used, therefore, it must be treated with an antistatic coating, which should be periodically reapplied. Acrylic sheeting should not be used as glazing for art objects that are powdery or susceptible to flaking, such as pastels, charcoals, or gouaches. Acrylic sheeting is easily scratched.

The following UV-filtering plastics are commercially available; UF-3 Plexiglas (Rohm and Haas), slight yellow tint, most effective absorption of UV radiation; UF-4 Plexiglas (Rohm and Haas), colorless, slightly lower absorption of UV than UF-3; Acrylite OP-2 (Cy-Ro Industries), slight yellow tint, comparable to UF-3 Plexiglas in absorption; Lucite SAR 1103 (Dupont), slight yellow tint, abrasion resistant, equivalent to UF-3 Plexiglas; Lucite SAR 1104 (Dupont), colorless, abrasion resistant, equivalent to UF-4 Plexiglas.

Adhesive

The materials composing an art object determine the type of adhesive to be used in its repair or mounting. Many adhesives have detrimental long- or short-term properties, or are unsuitable for use with certain kinds of materials. Among the many properties that are considered in determining the appropriateness of an adhesive are that it be nearly neutral in pH, that it be colorless and not liable to discolor or cause discoloration of the material on which it is used, that it be readily reversible and nonhygroscopic, and that it retain its bonding strength. Few proprietary adhesives are suitable for use with works of art. The appropriate adhesive for treatment and the means of removing it from an object are to be determined by a conservator.

Adhesive tapes

Glassine tape Commonly used for stamp hinges, this is often coated with a gum-arabic adhesive. Although glassine is not highly detrimental, its use is inadvisable on valuable works of art on paper, because of its acidity, lack of strength, and tendency to yellow.

Gummed cloth tape Linen tape coated with gum arabic, methyl cellulose, or a pressure-sensitive adhesive, used for hinging matboard. It should not be applied to art objects as the adhesive is not of adequately high quality and the thick tape may leave an indentation.

Japanese paper impregnated with a moisture-activated adhesive (including starch, paste, cellulose ethers, and various additives) for hinging lightweight works of art. These products (available from distributors of conservation and bookbinding materials) are the least detrimental of the commercially prepared hinges and tapes. Pressure must be applied to the slightly dampened surface in order to prevent cockling of the art work during the drying and setting process.

Pressure-sensitive tape Commercially produced pressure-sensitive tapes in common use today (transparent, drafting, self-adhesive linen, etc.) must never be used on art objects. The adhesive will penetrate porous materials, causing discoloration, and it may lift layers of paint, gold leaf, pottery glazes, fibers, etc. There is no universal solvent for pressure-sensitive adhesives. They are very difficult to remove, will leave a residue, and may stain the material to which they are attached. Nonbleeding acetate fiber tapes are safe to use with archival storage materials, such as Mylar folders, and for encapsulation.

Antistatic coatings

These are cationic surface-active compounds to be applied to both sides of acrylic sheeting (such as Plexiglas, Lucite, etc.) or plastic film (polyester such as Mylar, etc.) before such materials are placed in proximity with a work of art. These coatings, which have to be renewed at appropriate intervals, prevent the buildup of an electrostatic charge, and hence dust, for periods of several months. They are not, however, sufficiently effective to eliminate static charge completely, so that even treated acrylic sheeting should never be used with charcoal or pastels or surfaces that tend to flake.

Archivist's pen

A pen containing a permanent dye which, when applied as a small dot to a dampened area of paper or paper product (not to art objects), indicates by its color the product's general acid/alkaline level. It is useful for determining the pH of storage materials. A pH meter and nonbleeding indicator strips are other tools for measuring acidity.

Cleaning agents and polishes

In general, commercial or proprietary cleaners, whether they be treated dusting cloths, aerosol sprays, or abrasive polishes for silver and other metals, are not recommended, since they can be harmful in what they put on or take off. The formulas used in such products may also vary from time to time. Art objects in the Museum are to be cleaned only by a conservator.

Cotton batting

Used for cushioning objects in transit or storage. Where its fibers can cause or contribute to flaking (as on objects with vulnerable surfaces, such as ancient glass, painted pottery, etc.), batting should be wrapped in unbleached muslin or polyester fabric.

Encapsulation

Sandwiching of an archival document between two sheets of polyester film, such as Mylar, which are then sealed around the edges with nonbleeding pressure-sensitive tape. Encapsulation provides flexibility, visibility, and protection from handling and atmospheric pollution, but to maximize its effectiveness, the encapsulated material should be buffered first. Encapsulation is not used for works of art.

Erasers

Natural rubber and vinyl erasers Useful for removing surface dirt from mounting materials such as ragboard. Erasers are not to be used indiscriminately on any art object, as they may cause abrasion of surfaces and lifting of pigment. Some erasers, such as those made of rubber, leave residues that will eventually stain the art object.

Powdered erasers Soft, powdery eraser crumbs, packaged loose or in a cloth bag, used for removing surface dirt from mounting materials. Should not be used indiscriminately, as many surfaces can be disrupted even with gentle cleaning.

Ethafoam

An inert, firm polyethylene foam that is used for cushioning heavy, crated objects, and as a drawer and shelf liner. When works of art have delicate surfaces, a layer of tissue paper should be provided to guard against abrasion.

Feather dusters

Can snag and contribute to flaking, and should not be used on painted or splintery surfaces, if at all. A feather duster does not remove dust but merely relocates it.

Felt marking pens

Avoid their use on art objects, packing materials, or labels. The ink readily bleeds through layers of paper or fabric and is often indelible.

Fixatives

Synthetic or natural resins, intended to prevent offsetting of pastel and charcoal pigments, must never be applied to works of art in the Museum's collections, as they will eventually yellow and disrupt the tonality and texture of a picture.

Footcandle

Unit of measurement referring to the intensity of illumination from any source (natural, incandescent, fluorescent) on a surface. Since excessive light is dangerous to many works of art, footcandle levels are prescribed as a means of measuring and controlling exposure to illumination. The metric equivalent of the footcandle is the lux; one footcandle equals approximately ten lux.

Gloves

The use of gloved rather than clean bare hands depends on the circumstances and must be determined accordingly. Soiled gloves should never be worn when handling works of art.

Cotton gloves Recommended for handling metals, particularly swords, to protect objects from being etched by skin oils. In general, cotton gloves should not be worn when handling materials that flake, such as ancient glass, intricately worked objects, or smooth objects that may be difficult to grasp.

Plastic surgical gloves Useful for handling some flaking materials, metals, and objects requiring a good grasp.

HMI lamp

A flood lamp (high intensity discharge metal halide) used for television and film lighting, which generates comparatively little heat and is therefore potentially less damaging to sensitive art objects than most photographic lighting. Its spectral distribution closely resembles daylight. When used in the photography of art objects, the HMI must be filtered with appropriate acrylic sheeting to eliminate ultraviolet light.

Humidity meters

Psychrometers, recording hygrothermographs, dial hygrometers, and humidity indicator cards are devices used to monitor the percentage of relative humidity at a given temperature in a closed environment, such as a room, showcase, or frame, so that the amount of moisture vapor present may be maintained at the appropriate level for works of art in that area. The accuracy of the recording and dial instruments should be checked periodically with a wet-and-dry-bulb hygrometer.

Dial hygrometer A small instrument, usually about 1½ to 3 inches in diameter, with a humidity-sensitive device, used for measuring RH. Useful for showcases and confined areas, it should be mounted with access to air on all sides. Since readings tend to drift, the instrument must be frequently recalibrated. Some dial hygrometers also measure temperature.

Humidity indicator card (paper indicator) A paper card impregnated with cobalt salt bands which change color depending on the humidity level. The card gives only a general level of RH (in 10 percent units) but is very useful for monitoring small, confined, and hard-to-reach areas (such as that between picture and wall) and in packaging. The color ranges from blue (low RH) through

lavender to pink (high RH). High temperatures will affect readings, indicating a humidity lower than that which is actually present.

Liquid-crystal hygrometer An exceptionally accurate instrument that never requires calibration. Rather than a sensing medium such as hair or parchment, this hygrometer contains various chemical salts that respond to different humidity levels by rearrangement of their crystal structure, which is visible through a sheet of polarizing plastic. Because the salts are not self-illuminating, light is necessary to take a reading.

Recording hygrothermograph and hygrograph These instruments give a continuous, time-related graph of temperature and RH (or RH alone) over twenty-four hours or eight days. The recording pen is controlled by the tension of the moisture-sensitive element, usually hair strands within the instrument. The instruments need to be recalibrated every four to six weeks with a wet-and-dry-bulb hygrometer.

Wet-and-dry-bulb hygrometer (sling psychrometer, aspirating psychrometer) This instrument is used for the accurate measurement of RH and to calibrate all other hygrometers and hygrographs. It consists of two thermometers, the bulb of one wrapped in a dampened muslin sleeve, mounted so that they may be whirled around by hand—hence the term "sling psychrometer." A motorized version, known generically as an aspirating psychrometer (or an Assmann type), does not require manual operation and yields more reliable results. The measurement of RH is based on the difference between the two thermometer readings (in F or C): the dry bulb registers the temperature of the air; the wet bulb gives a lower temperature due to the cooling effect of evaporating moisture. RH is determined by referring to a chart or slide rule.

Lighting

Different sources of light emit different amounts of ultraviolet (UV) and infrared (IR) radiation. Neither IR nor UV radiation contributes to visibility, but both parts of the spectrum are damaging to many types of art objects. IR radiation will damage objects owing to the

effects of heat. UV light will cause problems such as embrittlement and fading of paper and textiles.

Daylight Has the highest proportion of UV radiation of all light sources. UV-filtering plastic (acrylic sheeting) must be used in front of sensitive objects illuminated by daylight.

Fluorescent tubes Emit little heat but must be covered with a sleeve of UV-absorbing acrylic sheeting to filter out high levels of UV radiation.

Incandescent lighting (tungsten, halogen quartz) Emits a negligible amount of UV radiation and therefore does not need filtering for this part of the spectrum. Because incandescent bulbs generate high levels of IR radiation, however, they must be kept at a distance from art objects so as to avoid heat buildup.

Light meters

Instruments equipped with a photocell to measure the amount of visible light falling on an object. The meter is placed close to the object, or parallel to the surface of a painting or drawing, with the photocell facing the light source. The unit of measurement is the footcandle or lux (see Part II, 1, Table 1 for recommended footcandle levels).

Ultraviolet monitor An instrument that measures the proportion of UV radiation (the band of invisible wavelengths of light at the violet end of the spectrum) in any illuminated area, whatever the light source—natural or artificial. The unit of measurement is the microwatt of UV radiation per lumen of visible light. Any source emitting more than 75 microwatts/lumen should be filtered with UV-absorbing material (acrylic sheeting).

Matboard. *See* Paper and paper products

Muslin

For conservation procedures and handling, unbleached, rather than bleached, muslin is used. Bleached muslin may be acidic owing to chemical residues.

Packing, storage, and transport materials
 See Cotton batting; Excelsior; Paper and paper products; Plastic
 sheeting; Polyester fabric; Polyethylene foam; Polyurethane
 foam; Solander box; Styrofoam nuggets

Paper and paper products
 Acid-free paper Rag-content or processed wood-pulp paper with a
 pH measurement that is in the neutral to slightly alkaline range
 (above pH 7), often referred to as buffered or archival-quality
 paper. It comes in a variety of types and weights, ranging from
 matboard to tissue paper, and is used where permanence and
 durability are important or where acidity in a paper would be
 harmful to the object with which it is in contact.

 Blotters Excellent as disposable working surfaces for examining
 or unwrapping art objects, and also as a support for transporting
 textiles and works of art on paper. Most blotters are not acid-
 free, and objects should therefore not remain in prolonged contact
 with them. Acid-free blotters are available with an approximate
 pH of 8.

 Buffered paper or board A paper or board of good-quality cellulose
 that is not only acid-free but also contains a reserve of alkaline
 compound for longer protection against an acidic environment.

 Cardboard, foam-cored boards, and other semirigid supports This type
 of material is used for storage purposes and as a backing in
 picture framing. It is easily dented and should therefore not be
 used as a substitute for a rigid support. Most of it is acidic; it
 may weaken in structure after a period of time and will react
 with organic substances. Unless known to be acid-free, it should
 not be placed in direct or prolonged contact with art objects
 sensitive to acidity. To determine if the material is chemically
 suitable for use, it may be tested with an archivist's pen.

 Glassine Translucent wood-pulp paper commonly used for
 interleaving and temporary wrapping. It has a tendency to darken
 and become acidic, and should therefore be replaced every few years.
 A neutral pH glassine is preferable for long-term use and is
 available from archival supply companies and paper manufacturers.

 Japanese paper Long-fibered handmade paper of generally high

quality and permanence, which is used for hinging and repairing works of art on paper.

Kraft paper, newsprint Highly acidic, chemically and mechanically processed wood-pulp papers, which are useful for temporary outer wrapping. They should never come in direct contact with works on paper or with textiles, or be used for storage purposes. Buffered kraft is an exception to this rule.

Nonbuffered paper and board Paper and board for use with certain textiles such as silk and wool, and with albumen and color photographs, which can all be damaged by an alkaline environment. It is made of high-quality cellulose pulp, contains no potentially harmful additives, and is in the neutral pH range.

Ragboard, rag paper High-quality cardboard and paper made of linen and cotton stock. Ragboard is used primarily for matting and mounting works of art on paper, parchment, photographs, and textiles. When new, both ragboard and rag paper are nearly or completely nonacidic. They are structurally long lasting and will not contribute to the breakdown of materials with which they are in contact.

Tissue paper Only acid-free tissue should be used with works of art. This lightweight paper, translucent or opaque, is useful for wrapping objects of all kinds, including metals, for padding and protecting textiles, for interleaving prints and drawings, and for lining storage shelves and drawers. Only nonbuffered tissue should be used with silk and wool and certain metal artifacts or for interleaving albumen and color photographs.

Pesticides

The possible long-term hazards to persons and art objects must be considered before any insecticide or fungicide is used. Many are extremely toxic to breathe and if touched may be absorbed through the skin. Some will cause irreversible changes in the molecular structure of art objects made of proteinaceous material. No liquids, aerosols, or powders used for pest control should ever come in direct contact with materials in a museum collection. Any insect that is found or mildew or fungus that is observed should be brought to the immediate attention of a conservator so that it can be identified

and an appropriate eradication program undertaken. Occupational Safety and Health Administration (OSHA) and National Institute for Occupational Safety and Health (NIOSH) toxicity references should be consulted before any pesticide is used.

The following chemicals have been used by the Museum and found effective as insecticides or fungicides:

Anoxants Oxygen-free environments utilizing argon or nitrogen. Unlike toxic chemicals, suffocation treatment causes the least change to art objects and is least hazardous to personnel. Administered in a sealed chamber over a three-week period. Recommended for insect control.

Sulfuryl fluoride ("Vikane") Should not be used for any art work without extensive testing. Will alter surface gloss on oil painting, may corrode metal and glass. Ineffective on some stages of insect life, so two exposures over several weeks are required. Is highly toxic. Administered by certified operators.

Paradichlorobenzene, napthalene Similar volatile solids generally used with textiles and ethnographic material. Will kill insects and larvae, but not eggs or fungi, when used in a sealed chamber. The crystal should not be placed in direct contact with art objects, as alterations in materials may result.

Thymol For fumigating mildewed works on paper, generally over a three-day period in a sealed cabinet containing low wattage bulbs, the heat from which will vaporize the crystals. Will dissolve oil paint, varnishes, some printing inks; may tarnish or stain photographs and damage parchment. Adverse environmental conditions will provoke reinfestation.

Lysol (Orthophenylphenol) Household spray effective for fungi and mildew. Alters some pigment systems and may cause yellowing of some materials. Not to be applied to art objects but may be used to disinfect their housing.

Plastic film
Cellulose triacetate Similar to polyester films (such as Mylar) in appearance and use but not as chemically stable.

Polyester sheeting Trade names are Mylar (Dupont) or Scotchpar (3-M Corp.). Processed from polyester terephthalate, these are among the most chemically inert of polyester films. They are transparent, flexible, impervious to moisture, and dimensionally and chemically stable. Archival-quality polyester film should contain no plasticizers, surface coatings, or UV inhibitors, and should not embrittle with age. Used to protect archival material (*see* Encapsulation), as a moisture barrier on the backs of frames, as a support for costume accessories, and for other purposes. It should not come in direct contact with art objects because it attracts dust. Polyester film with a reflective silver coating for use on fluorescent tubes offers protection from UV and visible radiation. These filters will transmit only 50 percent of visible radiation, whereas light yellow plastic UV-absorbing filters will transmit over 80 percent. They are used on fluorescent tubes in overhead lighting or vitrines and will not distort color rendition or significantly diminish light levels.

Plastic sheeting

Bubble wrap Fused layers of flexible, transparent plastic, with air pockets, usually made of polyethylene. Used for cushioning and for wrapping art objects in transport, and as shelf padding. At least one layer of acid-free tissue should protect the object from direct contact with the bubble wrap to guard against condensation, sticking, and the possibility of any other adverse reaction.

Plastic bags Transparent and opaque storage bags. Because condensation may collect in sealed bags, they should not be used for storing or packing art objects. It they are used, only those made of polyethylene, not polyvinyl chloride, are acceptable, and then only if the object is first protected by a buffering material, such as tissue or ragboard.

Polyethylene sheeting Inert plastic sheeting, used to protect objects in storage from dust. To prevent condensation and allow for air circulation, sheeting should not be tightly wrapped. An inner layer of unbleached cotton muslin or acid-free tissue is advisable. Because of the sheeting's tendency to attract dust, care should be taken that the side in contact with the art object is clean. It is advisable to check periodically all objects covered with plastic sheeting.

Polyvinyl chloride (PVC) An unstable plastic that is not recommended for use with art objects because it tends to exude chlorine vapors and sticky or acidic plasticizers. Commercial products such as Saran also contain PVC and should never be used to wrap metals or other art objects.

Plastic sleeves

Commercially available products made of UV-filtering acrylic (such as UF-3 Plexiglas), designed to be placed over fluorescent tubing in order to reduce UV radiation. Such sleeves do not alter the quality of visible light and are usually effective for about ten years.

Plasticine

A trade name for a pliable compound sometimes used for securing objects that are being photographed. Only sulfur-free plasticine should be used for this purpose, and it should be thoroughly removed from an object immediately after use. It must never be brought in contact with fragmentary or flaking surfaces, with broken edges where it may cause further damage, or with porous materials, such as earthenware, where it can cause staining.

Plexiglas. *See* Acrylic sheeting

Polyester fabric

Nonwoven, continuous filament fabric, available in different thicknesses. It is chemically inert, and resistant to moisture and mold. Folded in layers, it can be used as an alternative to cotton batting or muslin to cushion art objects. It can also be used to wrap cotton batting to prevent this from snagging on surfaces prone to flaking. (Two commercial products are sold under the names Pelon and Reemay.)

Polyethylene foam

Packing material, available in thick sheets that are easily cut to shape, which can cushion weight and reduce shock and is considered safe for long-term contact with art objects.

Polyurethane foam

An unstable packing foam that is not safe for long-term contact with art objects.

Ragboard. *See* **Paper and paper products**

Relative humidity (RH)

A percentage measurement of the relationship between the amount of moisture vapor in the air and the amount of moisture the air will hold when saturated (100 percent RH) at a given temperature and pressure. The higher the temperature, the more moisture vapor the air can hold. (*See* Humidity meters.)

Rubber

The sulfur content of rubber bands, rubber cement, and other rubber products will over the course of time cause dark stains on organic materials and will tarnish metals. Materials made of or containing rubber must never be used in contact with art objects.

Silica gel

A chemically inert, moisture-absorbing and -releasing compound used as a nonmechanical means of increasing, reducing, or maintaining relative humidity in an enclosed space. It is noncorrosive and nontoxic. Some types of silica gel granules contain an indicator dye which changes from blue to pink as moisture is absorbed; when heated, the silica gel is reactivated, whereupon the color reverts from pink to blue. Silica gel is available in small reusable canisters or as loose granules.

Fluctuations in RH in a showcase can be resisted by equilibrating silica gel to the required RH. Materials that absorb and release moisture in the environment, such as cotton, wood, or paper, can also be used in this manner.

Solander box

Devised for his specimens by D. C. Solander, the eighteenth-century botanist, this is a sturdy buckram-covered and paper-lined wooden box used for the storage of prints, drawings, photographs, and miniatures. The hinged lid fits over flanged sides, making the box dust- and light-proof. Storage boxes of similar design made of acid-free cardboard are also available.

Styrofoam nuggets

Not recommended as a packing material, as they are poor cushioning agents and useless for heavy objects, which immediately begin

working their way to the bottoms of crates. They also create a mess during packing and unpacking.

Tarnish-resistant materials

The use of these materials is to be determined by the conservator.

Antitarnish paper Paper impregnated with a sequestering agent which absorbs hydrogen sulfide from the air, thereby inhibiting tarnish formation on silver. May be used in display cases or for storage, but must never come in direct contact with objects.

Tarnish-resistant cloth Useful for lining shelves and containers where silver is stored.

Vapor phase inhibitors Used for the same purpose as antitarnish papers, these act by depositing a chemical compound on silver, thereby providing a barrier to oxidation. All such substances must be used with caution.

Ultraviolet-filtering plastic. *See* Acrylic sheeting; Plastic film: Polyester sheeting

Wax

Waxes may be used to secure objects for photography and exhibition but because of their varying properties should be prepared and handled only by conservators.

7. Suggested Reading

GENERAL

For the most recent literature consult *Art and Archaeology Technical Abstracts,* published by the Getty Conservation Institute, Malibu, Calif., in association with the International Institute for Conservation of Historic and Artistic Works, London.

Collins, Sheldan. *How to Photograph Works of Art.* Nashville: American Association for State and Local History, 1986.

Dudley, Dorothy H., and Wilkinson, Irma Bezold. *Museum Registration Methods.* 3rd rev. ed. Washington, D.C.: American Association of Museums, 1979.

Guldbeck, Per. *The Care of Historical Collections: A Conservation Handbook for the Non-Specialist.* Nashville: American Association for State and Local History, 1972.

Hunter, John E. "Emergency Preparedness for Museums, Historic Sites, and Archives: An Annotated Bibliography." *Museum News* 57 (April 1979); Nashville: The American Association for State and Local History, 1979. (Technical Leaflet 114.)

Mackison, F. W., Stricoff, R. S., and Partridge, L. J., Jr., eds. *NIOSH/ OSHA Pocket Guide to Chemical Hazards.* Washington, D.C.: U.S. Government Printing Office, 1980.

Plenderleith, H.J. *The Conservation of Antiquities and Works of Art: Treatment, Repair, and Restoration.* 2nd ed. (with A. E. Werner). London/New York: Oxford University Press, 1971.

Sandwith, Hermione, and Stainton, Sheila, compilers. *The National Trust Manual of Housekeeping.* Harmondsworth, England: Penguin Books in association with the National Trust, 1984.

Stolow, Nathan. *Conservation Standards for Works of Art in Transit and on Exhibition.* Museums and Monuments, XVII. Paris: UNESCO, 1979.

Thompson, John M. A., et al, eds. *Manual of Curatorship: A Guide to Museum Practice.* London: Butterworths, 1984.

Waters, Peter. *Procedures for Salvage of Water-Damaged Library Materials.* 2nd ed. Washington, D.C.: Library of Congress, 1979.

Willson, Nancy, ed. *Museum and Archival Supplies Handbook.* 2nd ed. Toronto: Ontario Museum Association and Toronto Area Archivists Group, 1979.

Zycherman, Lynda A., and Schrock, John Richard, eds. *A Guide to Museum Pest Control.* Washington, D.C.: Foundation of the American Institute for Conservation of Historic and Artistic Works and the Association of Systematics Collections, 1988.

MUSICAL INSTRUMENTS

Berner, A., van der Meer, J. H., and Thibault, G. *Preservation and Restoration of Musical Instruments: Provisional Recommendations.* London: Evelyn, Adams and Mackay for ICOM (International Council of Museums), 1967.

Dournon, Geneviève. *Guide for the Collection of Traditional Musical Instruments.* Paris: UNESCO, 1981.

Hellwig, Friedemann. "Restoration and Conservation of Historical Musical Instruments." In *Making Musical Instruments*, edited by Charles Ford. New York: Pantheon Books, 1979, pp. 155–175.

Pollens, Stewart. "Musical Instruments: To Play or Preserve." *Art and Antiques* 6:2 (1983) 40ff.

PAINTINGS

Keck, Caroline K. *A Handbook on the Care of Paintings for Historical Agencies and Small Museums.* Nashville: American Association for State and Local History, 1965.

Keck, Sheldon. "Mechanical Alteration of the Paint Film." *Studies in Conservation* 14 (1969) 9–46.

Pomerantz, Louis. *Is Your Contemporary Painting More Temporary Than You Think?* 2nd ed. Chicago: International Book Co., 1962.

Stout, George L. *The Care of Pictures.* New York: Columbia University Press, 1948; Dover Publications, 1975.

WORKS ON PAPER AND BOOKS

*Works marked with an asterisk give mounting procedures and formulas for paste.

*Clapp, Anne F. *Curatorial Care of Works of Art on Paper.* 2nd ed. Oberlin, Ohio: Intermuseum Conservation Association, 1974; rev. ed., New York: Nick Lyons Books, 1987.

Cuhna, G. D. M. *Conservation of Library Materials.* 2nd ed. Metuchen, N.J.: Scarecrow Press, 1971.

*Dolloff, Francis W., and Perkinson, Roy L. *How to Care for Works of Art on Paper.* 2nd ed. Boston: Museum of Fine Arts, 1977.

Ellis, Margaret Holben. *The Care of Prints and Drawings.* Nashville: The American Association for State and Local History, 1987.

Horton, Carolyn. *Cleaning and Preserving Bindings and Related Materials.* 2nd ed. Program of Library Technology. Chicago: American Library Association, 1969.

STARCH-PASTE FORMULA

1 part purified wheat or rice starch flour (available from distributors of conservation products and bookbinding materials)
3 parts distilled water

Mix together. Stir over gradually increasing heat until mixture thickens and becomes somewhat translucent. Strain until smooth. Refrigerate when not in use and discard when watery.